# SEVEN JOURNEYS

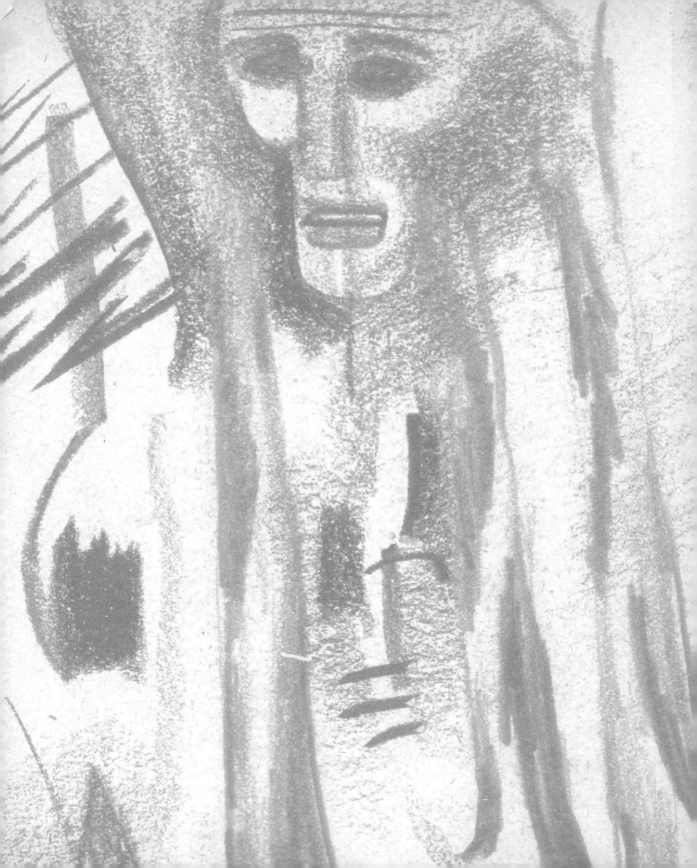

*Doris Shadbolt*

# SEVEN

# JOURNEYS

## THE SKETCHBOOKS

## OF EMILY CARR

*Douglas & McIntyre*
VANCOUVER/TORONTO

*University of Washington Press*
SEATTLE

Douglas & McIntyre
2323 Quebec Street, Suite 201
Vancouver, British Columbia V5T 4S7

*National Library of Canada Cataloguing in Publication Data*
Shadbolt, Doris, 1918–
     Seven Journeys

     ISBN 1-55054-922-7

     1. Carr, Emily, 1871–1945—Journeys.  2. Pacific Coast (B.C.)—
Description and travel.  I. Title.
ND249.C3S55 2002   759.11   C2001-911748-5

Published in the United States of America by The University of Washington Press,
PO Box 50096, Seattle, Washington  98145-5096
ISBN 0-295-98246-2

Editing by Saeko Usukawa
Cover and text design by Peter Cocking
Cover illustration: B.C. Archives PDP08732
Printed and bound in Canada by Friesens on acid-free paper ∞

All sketches are from the collection of the British Columbia Archives in Victoria.

We gratefully acknowledge the financial support of the Canada Council for the
Arts, the British Columbia Ministry of Tourism, Small Business and Culture, and
the Government of Canada through the Book Publishing Industry Development
Program (BPIDP) for our publishing activities.

CONTENTS

## FOREWORD

THE BRITISH COLUMBIA ARCHIVES in Victoria holds more primary records by and about Emily Carr than any other public institution. These include manuscripts and drafts for all the stories she wrote; her diaries and public speeches; an extensive correspondence to and from friends, family, artists and others in the art and publishing worlds; photographs of her and her family; voice recordings of people who knew or met her; and of course, hundreds of Carr's own sketches, watercolours and oil paintings.

Upon her death, Carr left a well-travelled steamer trunk filled with written records, sketchbooks, photos and memorabilia to her friend and literary executor, Ira Dilworth. In his will, Dilworth divided the contents of the trunk between his two adopted daughters, Edna Parnall and Phyllis Inglis. This material now forms the core of the B.C. Archives Carr holdings.

William Newcombe, a friend and anthropologist (and also an executor of Carr's estate), collected many of her sketches of

aboriginal villages along the coast. More than a hundred of these important early drawings are now part of the Newcombe collection in the Archives. In addition, many of Carr's friends, among them Edythe Hembroff Schleicher, Humphey Toms and Flora Hamilton Burns, donated her letters to them to the Archives.

Emily Carr was a complex and talented person. Her dual careers as artist and author, together with her compelling life story, ensure a wide recognition, both nationally and, increasingly, internationally. She left behind a large body of records providing information on her life, her feelings and her struggles, a legacy that will continue to enrich us.

The sketches presented in this book are yet another example of the richness of the archival record and demonstrate how Carr's personality stamped even the most fleeting of her artistic works. The British Columbia Archives is pleased to be a partner in this project.

*Gary A. Mitchell,* CRM
Provincial Archivist and Director
British Columbia Archives

ACKNOWLEDGEMENTS

WHEN I BEGAN WORK on this little book several years ago, I was already familiar with the collection of Emily Carr material at the British Columbia Archives. As the repository of the Carr sketchbooks, they were central to my research for this project, and I was almost totally dependent on their materials and services. I would like to thank John Bovey, who was then the head of the archives, for his positive and enthusiastic response to the project. I am also grateful to the B.C. Archives staff for their assistance and courtesy in responding to my frequent requests for access to the precious sketchbooks. Kathryn Bridge, in particular, was unfailingly gracious and generous with her help. I would also like to thank John Inglis for his permission on behalf of the Emily Carr estate to quote from unpublished papers in the B.C. Archives.

I am also grateful to my publisher, Scott McIntyre, for his determination to shepherd this project into print, and to my editor, Saeko Usukawa, for her sharp eye and her patience.

*Doris Shadbolt*

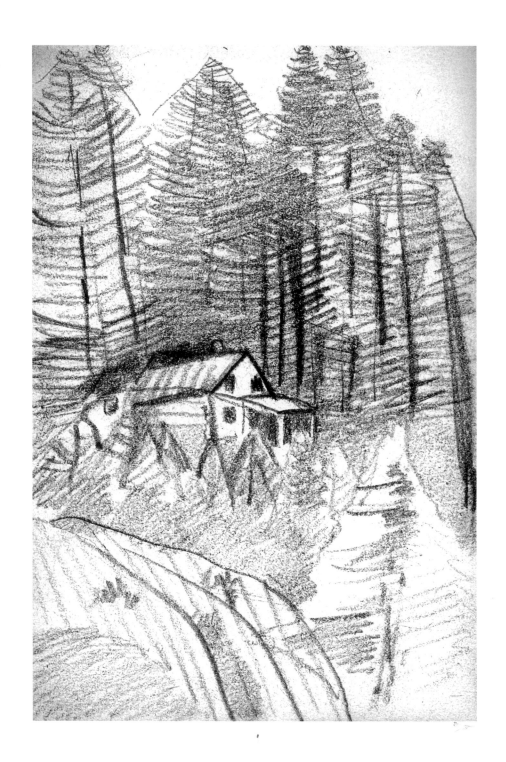

## INTRODUCTION

SOME YEARS AGO, when important Emily Carr archival material (presently held in the British Columbia Archives in Victoria) was still in Ottawa, I spent several weeks there in one of the quiet reading rooms of the National Archives. With the steady hum of the air conditioning filtering the occasional faint sounds made by other researchers, I read through the scribbler in which Carr had written a lengthy talk she had given in 1913, in connection with an exhibition of her paintings on Native subjects in Vancouver, letters she had written in later life to her friend and literary mentor Ira Dilworth, and other of her miscellaneous notes and jottings. But most of the time was taken in making my slow way through the sporadic journals she kept between December 1927 and 1941, four years before she died. These personal histories had already been published as *Hundreds and Thousands,* but I needed to check them for any pertinent material which might have been deleted in the editing process.

My reading was at the pace demanded by Carr's irregular, crabbed handwriting, often barely decipherable, carrying the expressive charge of her momentary mood or tension and pulsing with the imprint of a human mind and hand that script brings to paper. When I came to the end, my sense of having been close to this woman—of having been with her, of *knowing* her—was strong. And, as though I were leaving the theatre after watching a compelling play, I felt the shock of harsh late afternoon sunlight on a busy Ottawa street breaking my mood as I left the building.

Following the narrative of Carr's day-to-day encounters with the triumphs and disappointments of life as she sought to attain her painting and spiritual goals was sufficiently engrossing, but the effect was infinitely heightened by the sense of presence and immediacy which the handwriting brought with it. An artist's drawings, too, may have that extra dimension of attraction, that sense of summarized thought, of direct connection with the maker's eye, mind and body, especially if they were done as quick notations, uncomplicated by anxiety as to their worth, intended for no one's gaze but the maker's own.

Among the collections of Emily Carr material in the British Columbia Archives is a special cache of such drawings: thirteen

sketchbooks of the kind and make familiar to generations of art students and schoolchildren across Canada. Ten of them are horizontal books, six by nine and three quarters inches, made up of pages of coarse manila paper stapled down the centre, with soft covers that bear the familiar words "Ontario Blank Drawing Book" across the top, with maple leaves filling the interstices of a geometric line design. The three others, of slightly larger dimensions, belong to a different series, "The Canadian Blank Drawing Book."

Seven of the drawing books came to the British Columbia Archives from Edna Parnall, and the other six from Phyllis Inglis, nieces and adopted daughters of Ira Dilworth, and who, through him, had inherited Emily Carr's literary estate. I first saw the books many years ago, not too long after Carr's death in 1945, when they were still in private hands and before she had become the Canadian icon she is today. Then, it was still possible to pick them up without wearing protective gloves and to turn their pages. The inexpensive paper with its high wood-fibre content—a grade lower than newsprint—does not take long to become brittle and crumbling, and by the time I was able to examine them again, the books had been acquired by the British Columbia Archives, taken apart, the staples removed, and the separate leaves submitted to appropriate

conservation procedures. Today, yellowed with age and too fragile to be exhibited except occasionally in light-protected cases, the pages have been inserted in special Mylar sleeves and stored in dust-proof custom-made boxes. Even so far removed from their original format and everyday beginnings, they still carry their charge of immediate connection with the mind and hand that executed them—perhaps with an additional frisson now that they have become "precious" objects.

The drawings chosen for reproduction here represent but a fraction of the total number. Some were too slight or uninteresting, some represented ideas that did not succeed—and, in the case of several fine drawings, the pencil was too faint to reproduce. I have grouped them, for the most part, according to the original books they came from, though Carr (with her usual admirable unconcern for future students of her work) did not provide much help in ordering them. She had no need to date or identify such quick notes of often fleeting information, though occasionally, as in the case of some of the Skeena village sketches, she named the location to keep the record straight for herself. (I have retained Carr's spelling of Native place names.) And from what we know of her travels and other events that happened during those years, it is possible

to locate other drawings in time and place. The sketches within
each book do not represent a logical sequence in their execution;
sometimes, when the impulse struck her, she just grabbed the book
that was handiest, regardless of where the last drawing left off.
Sometimes there are blank pages, or two drawings to a page,
or written notes describing a passing scene or reminding her to
go to the post office or purchase canvas.

   Whatever their present museum context, these drawings
were not intended to be precious objects or artworks. They were
done as quick sketches to catch the salient features of a passing
scene, to note the characteristic form and rhythms of a tree, to make
preliminary experiments in the formulation of complex visual
material, to trap on paper her quickest thoughts. Given the purpose
of the drawings, and the conditions under which they were some-
times made—perhaps on the deck of a moving boat—it is inevitable
that many of them are artistically not very interesting in them-
selves. But as an indicator of part of Carr's process of making art and
as notes of several significant trips that she made between 1928 and
1930, they are fascinating. The selection presented here provides
a glimpse into that process and of the essence of those trips during
a critical period in her life.

# SEVEN

# JOURNEYS

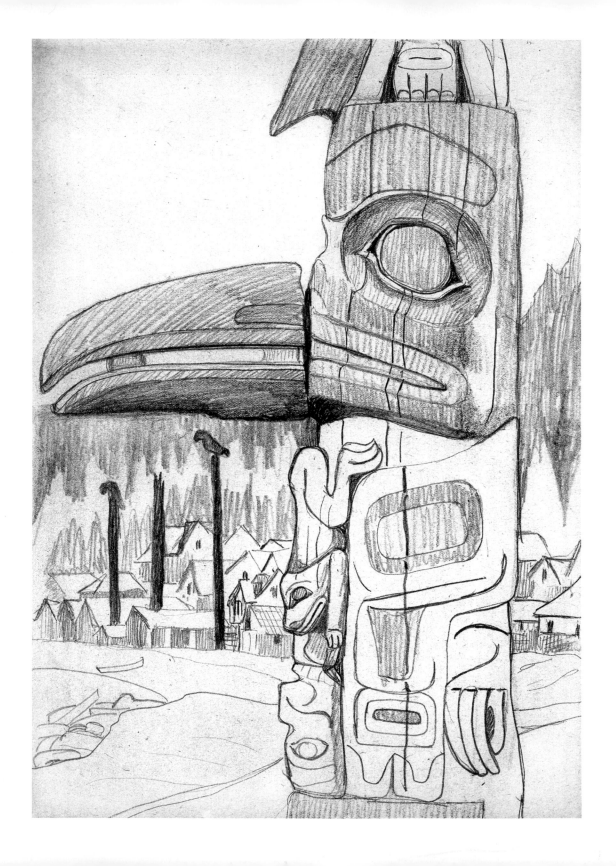

## Seven Journeys

THE TALE OF HOW Emily Carr, born in 1871, emerged from a cultural backwater and a patriarchal background in early Victoria, British Columbia, to become a luminous presence in the art of Canada has been told many times and in many different forms. Less well known are these modest little drawings, which play a part in the larger pattern of her evolving story, especially since they were done during perhaps the most interesting time in her life, in a period of critical change: artistic, spiritual and emotional. The first such drawing was made on December 4, 1927, and the last was done sometime at the end of the summer of 1930. Although that beginning date was only a few days before her fifty-sixth birthday, and although she had already produced a large body of accomplished work, the time of her fully mature painting was just about to commence. The sketchbooks affirm two aspects of that accomplishment: firstly, that she had joined the ranks of modernist artists; and secondly, that the first-hand study of the cultures of

west coast Native people of British Columbia had provided the subject matter for much of her work.

Today, Emily Carr is known as a modernist by art historians, something that would have pleased her even if she would not have known the full implications of the term. Certainly, she wanted to be "modern" and, at a certain point in her evolution, took steps to become so, but she was not knowingly a player in the larger field of art history. And, in any case, "modernist" and "modernism" were historical concepts still awaiting the articulated emergence of "postmodernism" for their own full definition. Carr's entry into the modernist camp had come about quite suddenly in 1911–12, with her sojourn in France, where she had gone with that conversion in mind. Previous periods of study and exposure to art in San Francisco and England had failed to shake her out of the backward, amateurish, Old-World notion of art that was all she had to inform her while she was growing up in Victoria. In France, she showed an ability to make a quick and critical changeover when the time was strategic, an ability that she would demonstrate again some fifteen years later as she developed her version of a kind of generic Post-Impressionism. Abandoning the watercolour medium so favoured in Victoria by an English-oriented society, she began working in oil

with a vibrant colour palette, demonstrating a sense of the materiality of pigment and a shift in painterly vision from a depicted subject viewed someplace beyond the picture surface, to the surface itself.

Even before her artistic transformation in France, Carr had been awakened to the cultural riches of the Native peoples of coastal British Columbia. Native people from nearby reserves had been part of the daily Victoria scene as she was growing up: paddling their canoes in the harbour, selling their baskets of fish or berries on the wharf, working at jobs for white families like her own. But until she was thirty-six years old, she had not seen Native people still managing to live more traditional lives away from the city, close to nature and in villages where totem poles were still standing. (She had seen something similar in her 1899 visit to Ucluelet, but the Native people there did not carve totem poles.) That occurred during a visit with her sister Alice to Alaska in 1907. It was a visit that turned out to be important for her, for, there in the north, she located a major theme to which she could harness her art. On the way home down the coast, she made the decision to undertake a visual record of Native totem poles in their village sites before they disappeared.

After a first excursion in 1908, by 1912 she had made several trips to Native villages on the northern part of Vancouver Island, to

the Skeena and Nass River areas of the mainland and to the Queen Charlotte Islands (which the Haida now call Haida Gwaii), gathering visual material in the form of drawings, watercolours and notes for what had become an obsessive pursuit. In the beginning, this direction her art was taking was undoubtedly career-oriented; she had ambitions for her art, and this was a challenging and serious undertaking. And the fact that she was embarked on a mission unusual for a woman of her time and place probably satisfied a strong ego need to be "different." Then, too, she was able to glimpse in the more remote villages, however imagined and romanticized her perception, a way of life and of the Native people who still lived it that appealed to her as simpler, more dignified and more honest than that to be found in propriety-bound Victoria.

Emily Carr's stated admiration for the Native people whom she encountered on her travels and who helped her on her trips inevitably involved the unconscious assumption of her own social superiority. There was the enormous cultural difference between them and herself, while at the same time their years of endured oppression had bred in them a reserve and lack of trust, all of which made it impossible for her to know any of them on a fully communicative footing. Still, she could see them as the rejected "others," a sympathetic echo of her own condition, for her passionate

devotion to her art (as well as other of her practices that were viewed as eccentricities in Victoria) frequently made her feel alienated in her own society. In any case, in the years ahead, what she identified in the beginning as a documentary record would, apart from geographical discovery, take her and her art into territories of the mind and imagination that she could scarcely have foreseen.

As a result of these early trips, Carr was able in 1913 to assemble in Vancouver a large exhibition of more than one hundred paintings that clearly demonstrated her commitment to modernism and the Native theme. The modern way of painting which she had brought with her from France may have been fairly familiar there, but on the west coast of Canada, in any case the last part of the country to receive the shocks of cultural change, the intense colour and the sacrifice of verisimilitude that characterized much of the work in the show were found to be too challenging. Added to their modernity was the fact of their Native subject matter, which was in contrast with the landscapes, portraits and still-life studies preferred by unsophisticated viewers. And, of course, there was then no supportive critical audience, even though the climate for art was a little better in the larger city of Vancouver than in Victoria. So this ambitious show, which marked the high point of Carr's artistic achievement to that point, was construed by her as a failure, a

failure which might well have signalled the end of her painting life, considering the many other discouragements she had already encountered. Instead, it marked the beginning of a slackening off of creative energy that was to last for some fifteen years. The small landscapes she painted in those years were brilliant (often Fauve-like) in colour and vigorous in brushwork, but there were few of them in comparison with the prolific output of preceding years.

Unable to earn a living through the sale of her painting, in 1914 Carr constructed a small, four-suite apartment building in Victoria, with her share of the inheritance from her father's estate. She intended to live off the rental income from three of the suites and to use the fourth as her painting studio. But the year 1927 found her still trapped by the double snare of economic necessity and artistic discouragement, playing the role of reluctant landlady, a role she would continue to play for eight more years. In later life, she was able to exorcise the anger of these years against her tenants and the circumstances which had tied her to them in her bitter and funny book, *The House of All Sorts*.

In her fifty-sixth year, early in 1928, Carr began painting once again, like a tap suddenly turned on full force, with a strength and conviction that made the previous forty years of production appear

almost like a protracted period of preparation. Her paintings
dealing with Native subjects were responsible for the resurgence.
All during those early years when she had been travelling to Native
settlements and diligently making paintings from the things she
saw—and sentimentalizing the Natives from her distance—Carr
probably had not thought about the political implications of their
situation. And no doubt she was unaware that she was in fact fitting
in with the Canadian government's plan to absorb the original
inhabitants of the country. That plan, implemented through legis-
lation and supported by various churches and the work of their
missionaries, included not only taking over Native lands but also
an attempt to destroy their culture by outlawing rituals, insisting
on anglicized names, forbidding the use of Native languages in
residential schools and imposing Christianity on their traditional
beliefs. Embracing what by this time had come to be recognized
as their art into a larger definition of Canadian art was also part of
this plan, the ultimate goal of which was to help foster a strong
sense of unified nationhood both at home and abroad.

A small but significant part of the government's program
was the organization in the nation's capital of an exhibition called
*Canadian West Coast Art, Native and Modern,* whose purpose was

to "mingle for the first time the artwork of the Canadian West Coast tribes with that of our more sophisticated artists," a venture jointly sponsored by the National Gallery and the National Museum of Canada. Carr's visits to Native villages (especially an extensive northern trip in 1912), and the work she had done there, had become known to Marius Barbeau, an eminent Canadian ethnologist who had been conducting research in British Columbia. This led to an invitation to Carr to take part in the show. It probably mattered little to her that it was the subject matter of her painting rather than the quality of her work that attracted the organizers' attention. Her twenty-six paintings shipped to Ottawa included both her pre- and post-French styles, as well as several of her hooked rugs and pottery pieces with Native designs, which she had been making to supplement her income. Other non-Native Canadian artists, mostly from eastern Canada, were also included in the exhibition: Edwin Holgate, A.Y. Jackson, Anne Savage, Pegi Nicol, W. J. Phillips and the sculptor Florence Wylie, all of whom had made brief trips to west coast Native settlements, following ethnologist Barbeau's encouragement, though none of them had the sustained commitment of Carr.

This event—her first inclusion in a Canadian show of national significance and the free train ticket which took her to eastern

Canada for the opening—signalled the most critical turning point in both Carr's art and her life, for it offered her a connection with informed criticism, exhibiting opportunities and potential buyers for her work. Even more important, that trip brought about two important changes in her outlook: her belief in herself as an artist was restored and strengthened, and she gained a new vision of what it might mean to be an artist, one that set her art on a new course. She embarked on several years of intense study and experiment in which she grappled with and began to synthesize into her own full expression the implications of her newly expanded horizons.

Starting with that historic trip to eastern Canada, Carr filled thirteen sketchbooks in the short but critical span of three years, a period of concentrated rethinking and change from she would emerge fully realized, like a butterfly from a prolonged cocooning. In the drawings, we see her working away at methods of moving toward new artistic goals and of going out to gather fresh visual material into which she could incorporate her new insights. Indeed, the sketchbooks are in a way traces of those, as is a series of other journeys Carr made in the three years following that pivotal first one at the end of 1927; they embody both journeys to real places in real time and journeys of the mind as she made her way into new artistic territory.

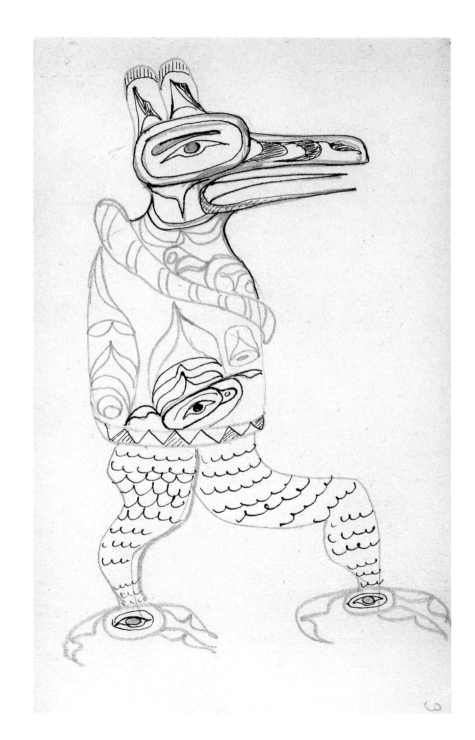

JOURNEY ONE

# Toronto, Ottawa and Montreal, 1927

THE RESTORATION OF Emily Carr's confidence in 1927 was partly due to the simple fact of her inclusion in the important national exhibition, *Canadian West Coast Art, Native and Modern,* a decision made by art officials. But she also needed the approval of her artistic peers to confirm that decision. On her journey to Ottawa, she stopped off in Toronto, where there was by now an established art scene, and she was taken in hand by the leading circle of the artists' community, those around the Group of Seven.

By this time, the members of the Group of Seven, with the support of the National Gallery, were well known as the most significant artists in English-speaking Canada. Carr, isolated on the west coast from the larger art world in eastern Canada, had heard of their existence for the first time just prior to her departure and had learned about their nationalist mission and ideology from Frederick B. Housser's defining book about them, *A Canadian Art Movement.*

To be welcomed by them, even praised as a worthy painter colleague, was an almost overwhelming affirmation of her own painter's stance. She who—dispirited by the absence in Victoria of a sympathetic and supportive artistic community and worn out by her tiresome responsibilities as landlady—had seemed for fifteen years almost to have abandoned art as an urgent compulsion, returned to full-time painting within a fortnight of her return home. There would be times of discouragement in the future, but never again would her drive to make art fail her.

In the members of the Group of Seven, Carr encountered artists who represented for her a somewhat different notion of what art is and does. It was not just a matter of style or subject but of attitude and a range of personal involvement. Her early work, after San Francisco and after England, shows her as an "eye" (seeing "things" that were more or less interesting) and a trained hand (one that knew how to depict those chosen things). Even the vibrant, colourful approach she had picked up in France essentially represented a way of "seeing" things like a super-sensing spectator; the "feelings" generated were sensory, not subjectively emotional. It was Lawren Harris who first seems to have opened up to her the possibility that an artist might draw on other levels of his/her resources: those psychic or spiritual. On first seeing his austere northern landscapes

ONTARIO
BLANK DRAWING BOOK

BOOK N

80 Pages, Exclusive of Cover, Sheets Full Size, 6 x 9 in., Evenly Perforated for Detaching
Specially Prepared for Pencil, Crayon and Water Color

W. J. GAGE & CO., LIMITED - TORONTO

*(Cover of Ontario Blank
Drawing Book)* 1927
15.2 × 24.8 cm
B.C. Archives PDP08868

Inscribed "Ottawa"

*Stone Vessel* 1927

Graphite on paper, 15.2 × 24.8 cm

B.C. Archives PDP08845

Drawn from an artifact
in the Canadian Museum
of Civilization

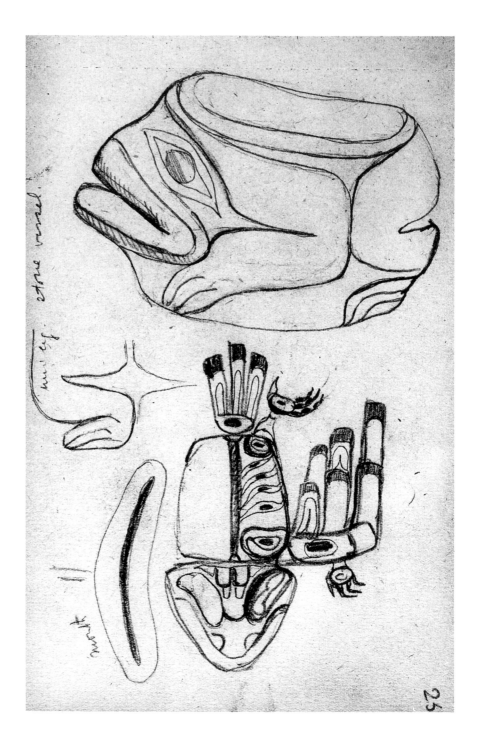

with their infinite spaces and stringent light, she was profoundly moved by what she, given her temperament and terms of understanding, thought of as religious feeling

One of the pages reproduced here (page 29) reveals Carr's reaction on December 4, 1927, on entering the room in the old Art Gallery of Toronto where paintings by the Group of Seven were hung: "Harris's are at the end of a big gallery they are *alone* somehow when you enter the gallery the others die they are a different time a different place a different world. There is always that dignity & spirituality, spaces filled with thoughts that rest soothe comfort make you so happy."

And again on December 13 (the day after her fifty-sixth birthday), just before returning home to Victoria, she wrote about Harris in her diary, "I see that for him, art and religion are one," for her a stunning revelation of possibility that she would incorporate into the goals for her own painting and articulate in her own words in the years ahead. Theosophy, Harris's recommended route to spirituality, was too cerebral and detached from human emotions for Carr, though she struggled with its ideas for several years before abandoning them; we can, however, see them at work in some of the drawings. The search for a spirituality of her own that her painting

could carry, she found eventually by heading straight into nature, the kind of nature that the west coast had abundantly to offer.

Carr was never a traveller for the journey's own sake. She had gone to England and France, as to San Francisco before that, not as a sightseeing tourist but to study painting. On this important trip to eastern Canada, where she was treated like the honoured visitor she was and her itinerary largely was determined by others, she was thinking of the art she would make on her return and took the opportunity to make notes as chances arose. With her long pursuit of west coast Native subjects so clearly validated by her prominent inclusion in the exhibition of Canadian west coast art, she wasted no time in getting back to that theme, taking advantage of her stay in Ottawa to draw from the collection of Native work at the National Museum of Canada (now the Canadian Museum of Civilization). As she had been many years before when drawing from museum objects in Victoria, here again she was faithful to the character and detail of the Native designs. She almost filled a book with these Ottawa drawings, of which only a few are shown here, but throughout the thirteen volumes there are other drawings that she made from illustrations in the books of ethnologist Franz Boas and from other books and museum sources.

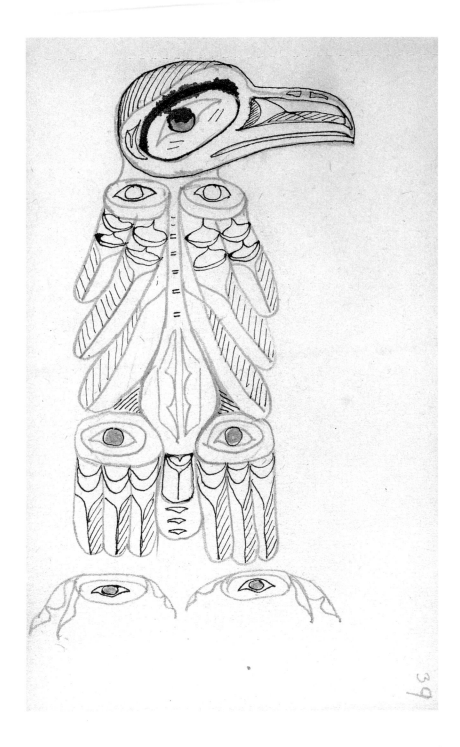

*(Design of bird)* 1927
Graphite on paper, 24.8 × 15.2 cm
B.C. Archives PDP08858

Drawn from an artifact
in the Canadian Museum
of Civilization

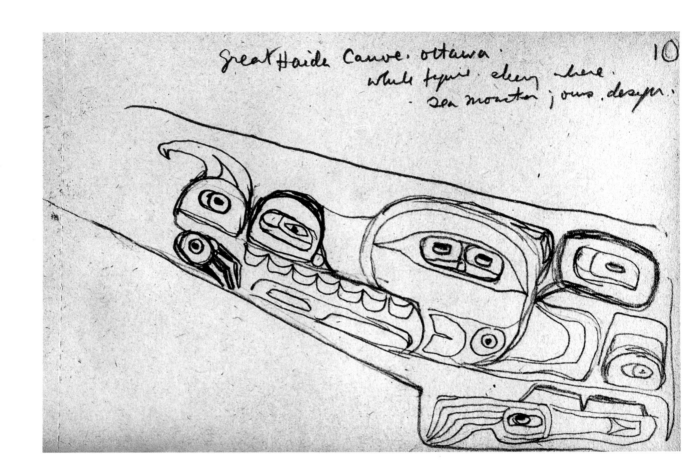

*Great Haida Canoe,*
*Ottawa* 1927
Graphite on paper, 15.2 × 24.8 cm
B.C. Archives PDP08831

Drawn from an artifact
in the Canadian Museum
of Civilization

*Sea Monster, Front Figure
on Great Canoe* 1927
Graphite on paper, 15.2 × 24.8 cm
B.C. Archives PDP08832

Drawn from an artifact
in the Canadian Museum
of Civilization

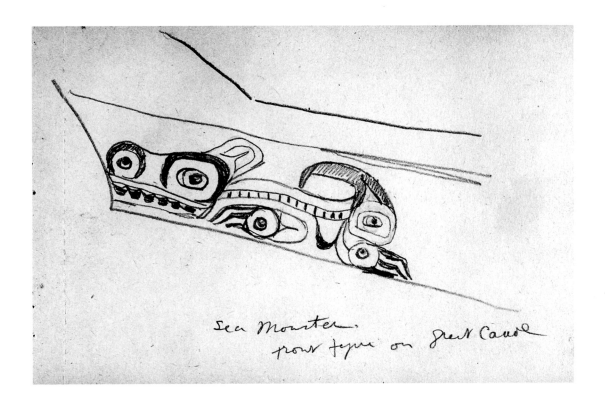

*(Handwritten text)* 1927

Graphite on paper, 15.2 × 24.8 cm

B.C. Archives PDP08868

reverse side 1

Dec 4
I am at the 'Grange' a last look before going home there is a little picture Ex. on. They have moved West Wind. It is not in quite such a good place, but always wonderful, it is not so very large. The color is luscious. The foreground is rocks, there are warm & cold reds, rich greens purple greys. The thin trunks of the pines are red. One is thick & another solid but the other two have been beaten & twisted by the wind the leaves hang heavily in blobs of warm green with the cold red stalks the sky is full of breezy clouds stormy wind tossed & the hills are blue & green dull and [?]. The water is full of color & movement.

———

A beautiful small J.E.H. McDonald hangs next, in color & design it is joyously beautiful the mountains are draped in heavy mist forms solidly put in swirly masses there are two red canoes & reflections.

———

There is a delightful Jackson here too

*(Handwritten text)* 1927

Graphite on paper, 15.2 × 24.8 cm

B.C. Archives PDP08868

reverse side 2

It is easy to pick out the Group things they are so much bigger in feeling. McDonald's group of 7 small ones are mostly rockey [*sic*] [?], strong & delightful in color & mood

———

Jackson's are big swell things all different snow autumn & sunshine

———

Casson's don't interest me

———

Lismer's are boring I feel the paint a little, how I wish I could do as well

———

I can't feel Carmichael.

———

Harris's are at the end of a big gallery, they are *alone* somehow when you enter the gallery the others die they are a different time a different place a different world. There is always that dignity & spirituality, spaces filled with thoughts that rest soothe comfort make you so happy

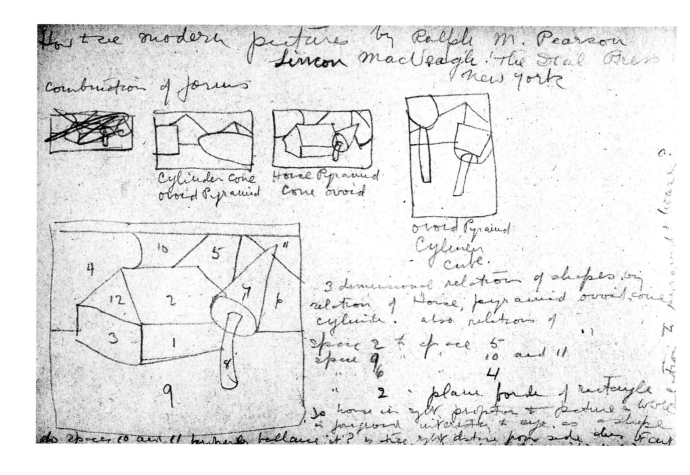

How to see modern pictures by Ralph M. Pearson

Simeon MacVeagh & the Seal Press
New York

Combination of forms

Cylinder Cone
ovoid Pyramid

House Pyramid
Cone ovoid

ovoid Pyramid
Cylinder
Cube.

3 dimensional relation of shapes by
relation of House, pyramid ovoid, cone
cylinder. also relation of
space 2 to space 5
space 9 10 and 11
" 2 plane form of rectangle
to house in get proportion + picture + world
in foreground interesting to eye. as a shape
to space 10 and 11 which a balance it? to the right distance from side, also to any

facing page:

*From How to See Modern Pictures by Ralph M. Pearson* 1929?

Graphite on paper, 15.2 × 22.9 cm
B.C. Archives PDP05733

Sheet of designs based on those in the book *How to See Modern Pictures* by Ralph M. Pearson, published in 1928

JOURNEY TWO

# *Toward Abstraction, 1928 and Onward*

IT WAS LAWREN HARRIS chiefly who started Emily Carr on an exploratory path in the direction of abstraction. The formative notion she had received on first meeting him was that the role of the artist was *expressive* rather than *depictive,* whether or not the expressiveness was to be symbolically-mystically inclined as was his (and hers would be) or otherwise directed. Apart from his value as an exemplar and his moral support, Harris offered critical advice that could almost be summarized as "strengthen [your] design," for when he first saw Carr's work, she was still "entrenched behind the buttresses of Impressionism and its offshoots" (to use a remark that American artist Mark Tobey would soon make). And *design* continued to be the central message of Harris's counsel to Carr as his mentoring continued through the next four years by correspondence.

Coincident with this help from Harris, Carr had a brief but important connection with Mark Tobey, who gave what she called

a three-week "advanced course" in her Victoria studio in September
of 1928. His advice was more specifically pictorial than Harris's, but,
in general, he, too, urged her to more structure, more formalization;
and, as it happened, he was conducting his own experiments in
cubism at the time.

In addition, there was a third important influence in what
might be called a structural turnaround in Emily Carr's style at this
juncture. That was a book which Tobey had used in his teaching,
Ralph Pearson's *How to See Modern Pictures*, of which Carr obtained
a copy. Very much in the stream of current art theory and training
of the time, the book combined practical analysis along with an
assertion of art's deep expressive values. Pearson, too, placed great
emphasis on design, "which the modern movement had rediscov-
ered . . . as one of the most essential qualities which determine a
work of art." Following the observation of French artist Paul
Cézanne, he pointed out that all forms in nature could be reduced to
primary geometric solids so that "a mountain is a cone or pyramid, a
tree top is a cube, sphere or ovoid, its trunk a cylinder," a necessary
process of abstraction in the artist's search for "inner realities."

The combined impact of Harris, Tobey and Pearson's book—
together with the experiments other artists were making in the
direction of abstraction that Carr was seeing, if only in books and

*(Handwritten text)* 1929?

Graphite on paper, 15.2 × 22.9

B.C. Archives PDP05722

A transcription of the text
appears on page 36

*(Shapes of human parts)* 1929?

Graphite on paper, 22.9 × 15.2 cm

B.C. Archives PDP08763

magazines—all resulted in the stylistic change that took place in her work in 1928–29. Those results are visible in canvases such as the well-known *Indian Church* (1929), in which entire trees and their complicated foliage are carved and chiselled into a micro-structure of solid geometric forms, overlapping, curving, zigzagging. But before the paintings, the drawings show what were perhaps her first attempts to absorb the advice about design she was receiving and to apply it. In one drawing (page 30), she shows herself an earnest student (age fifty-seven), faithfully copying diagrams from Pearson's book: cubes, cylinders and cones, followed by drawings of cubic "lay" figures and, finally, a totemic carved figure, cubically analysed.

In another drawing, Carr copied one of Pearson's diagrammatic analyses of houses, trees, hills and other landscape forms into cones, cylinders, cubes and so on. Tobey had done a painting based on the interior of Carr's studio with all its paraphernalia, and she, too, following his thought, made compositional sketches of the same chairs, lamp, typewriter and so on (page 39). Such sketches show how seriously she was attempting to imprint on her mind the formal principles supplied by her instructors Pearson and Tobey.

More interesting in themselves, and often very beautiful, are Carr's sketches of trees, singly and in groups, as she experimented

with various ways of formalizing and "abstracting" the confusion of detail presented in nature. There are several experiments with highly stylized landscapes, and one in which lines angle their way across the paper to produce an intriguing "minimalist" composition (page 44).

These little studies lie behind Emily Carr's deep and dark forest and totem paintings, with their formalized and structured trees. She was, however, not interested in following the path to abstraction for its own sake but only as a means to an "emotional" end. Making this point clear, she noted the following instructions to herself on one of the sketchbook pages (page 33):

Things to be remembered in abstracts:

Symbols & design may be used but design must be all over pattern leading out in all directions as if it were continued limitless but should be unified and a concrete thing in itself.

Keep masses well defined light & dark do not have shapes & forms the same size nor color but get variety of lines & spaces not too broken up peice [sic] of small pattern amongst large masses above all go for the *emotional* idea of the whole. Realistic proportion not necessary—entire liberty of the individual in work.

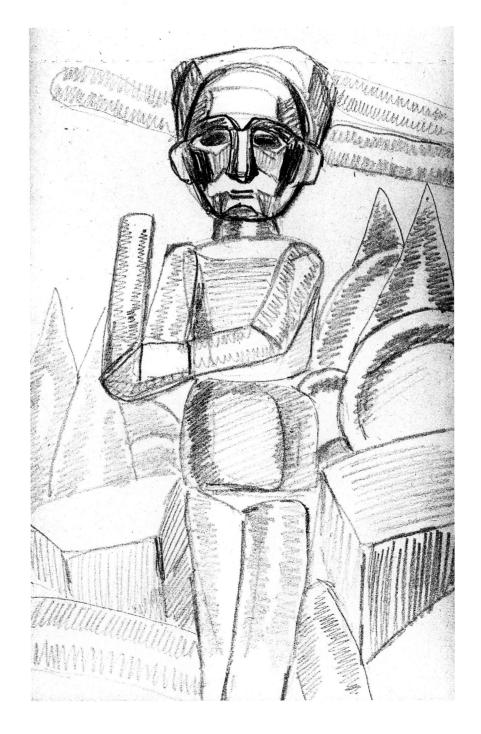

*(Stylized drawing of a totem pole in the spirit of Pearson's book)* 1929–30
Graphite on paper, 24.1 × 14 cm
B.C. Archives PDP08766

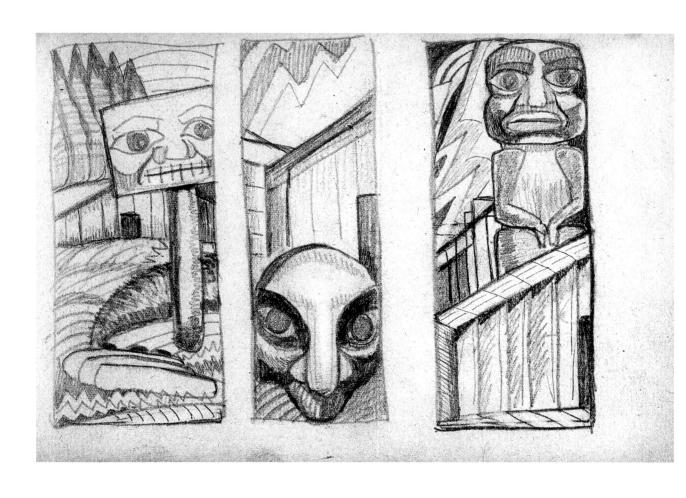

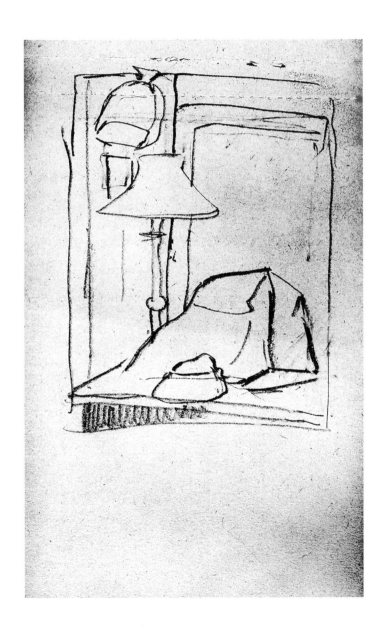

facing page:
*(Three stylized drawings*
*of totem poles)* 1929–30
Graphite on paper, 15.2 × 22.9 cm
B.C. Archives PDP05726

this page:
*(Drawing of Carr's studio)*
1929–30
Graphite on paper, 24.1 × 14 cm
B.C. Archives PDP08768

this page:

*(Abstract drawing of tree forms)* between 1929 and 1940

Graphite on paper, 24.8 × 15.2 cm

B.C. Archives PDP08903

facing page:

*(Stylized drawings of totemic forms)* between 1929 and 1940

Graphite on paper, 15.2 × 22.9 cm

B.C. Archives PDP05730

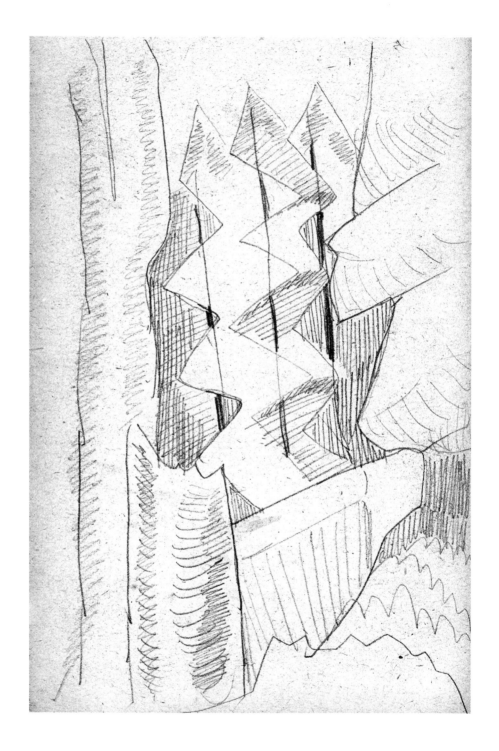

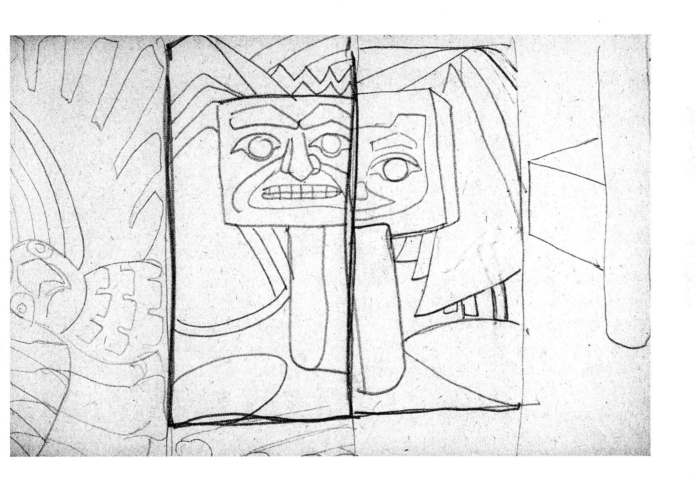

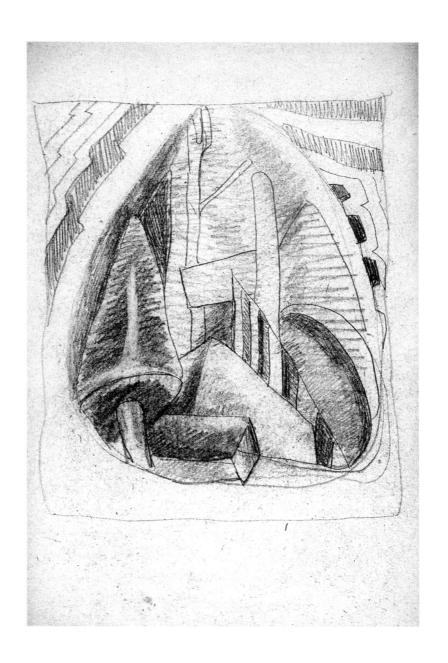

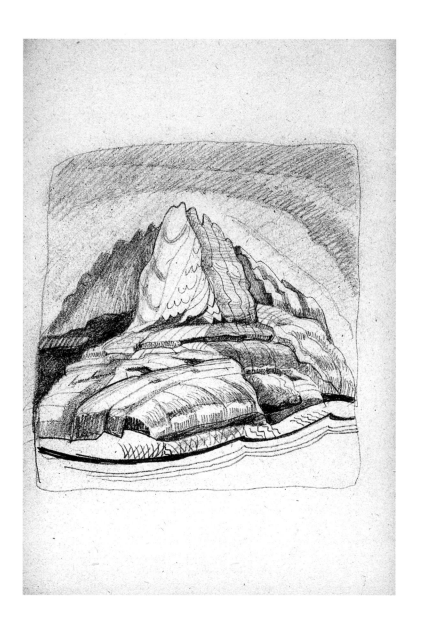

facing page:

*(Stylized design based on forest forms)* between 1929 and 1940
Graphite on paper, 22.9 × 15.2 cm
B.C. Archives PDP05738

this page:

*(Abstract drawing of landscape forms at sea edge)* between 1929 and 1940
Graphite on paper, 22.9 × 15.2 cm
B.C. Archives PDP05739

this page:
*(Abstract drawing of shore edge and reflections in water)* between 1929 and 1940
Graphite on paper, 15.2 × 24.8 cm
B.C. Archives PDP08911

facing page:
*(Formal tree study)* between 1929 and 1940
Graphite on paper, 31.8 × 22.5 cm
B.C. Archives PDP08748

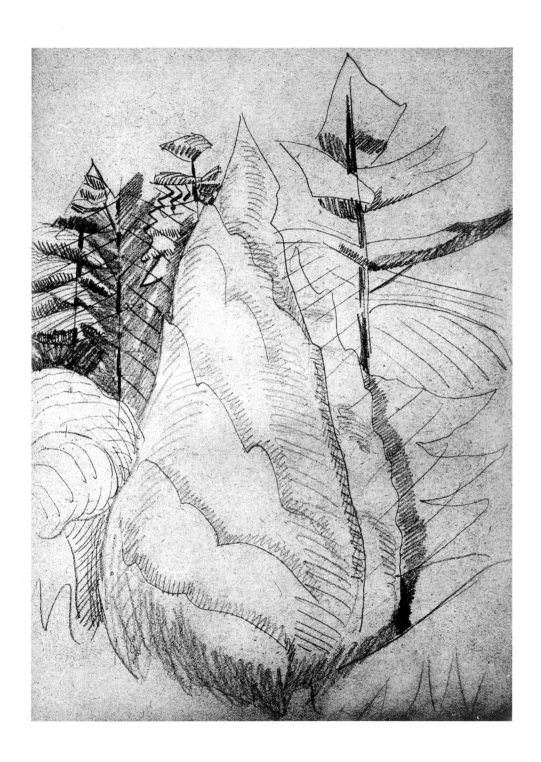

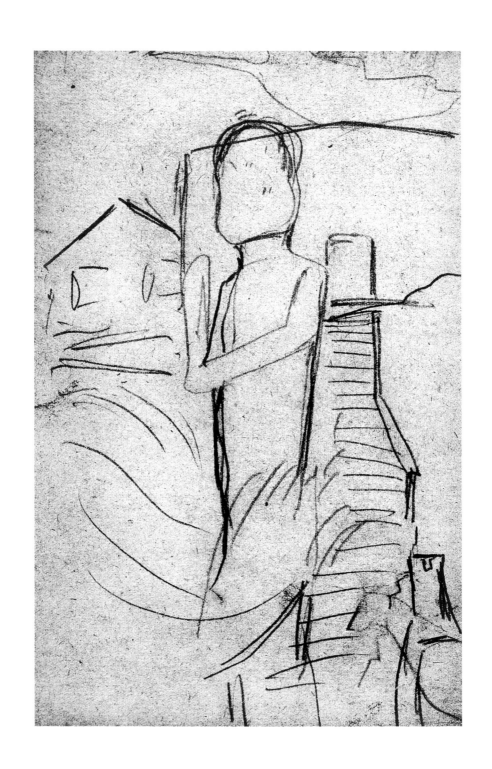

facing page:

*(Figure at Mimquimlees)*
1928?
Graphite on paper, 24.1 × 14 cm
B.C. Archives PDP08894

Probably done at the
Kwakwaka'wakw village of
Mimquimlees at the
beginning of Emily Carr's
1928 trip after visiting
Fort Rupert. The Vancouver
Club has a canvas of the
same subject.

JOURNEY THREE

# *Skeena and Nass Rivers and Queen Charlotte Islands, 1928*

WITH HER INTEREST in the Native theme rekindled by the Ottawa trip, Emily Carr decided to undertake further journeys to Native sites. There were four such trips altogether, and while the drawings do not tell the whole story—for she used other forms of note-taking as well—there are references to all of them in these particular sketchbooks.

Waiting only for the arrival of summer weather after her epiphany in Ottawa and Toronto, Carr set out at the end of June 1928 on a second trip to the far northern villages. (The first one had been made in 1912, and from it she had reaped a large harvest of drawings and watercolours, many of which today are in the Newcombe collection in the British Columbia Archives.) For this second northern trip, Carr was more experienced in the ways of travel, though many destinations were still well off the beaten tourist track and often difficult of access, even with the help of local government agents,

boat captains and the many Native people on whom she relied. And, of course, she was sixteen years older. Her sense of mission now fortified by the approval of her peers, she hoped that this second experience would be even more rewarding than the first and accordingly set out on an ambitious itinerary planned to take two months.

Sailing north by steamer on the first lap of her journey, always in the company of her beloved dog Ginger Pop, Carr stopped to visit Alert Bay, Fort Rupert and perhaps other Kwakwaka'wakw villages on the northern tip of Vancouver Island. There were adventures aplenty. At Fort Rupert, while sketching, she was chased by wild bulls and, with Ginger Pop in one hand, had to climb onto the roof of a rickety woodshed to wait for rescue and to be taken to her next destination (Alliford) in the canoe of an accommodating Native man.

On the mainland, she proceeded by train up the Skeena River, visiting the Gitxsan villages of Kitwanga, Kispiox and Kitsegukla. She found that the poles had deteriorated greatly since her previous visit and was distressed that many of those at Kitwanga had been removed from their places on the river, desecrated with commercial paint and erected along the tracks near the railway station, "catering," as she complained, "to the beastly tourist."

*(Hilltop with totem pole)* 1928?

Watercolour on paper

15.2 × 22.9 cm

B.C. Archives PDP05762

This may have been sketched
at Kitwanga

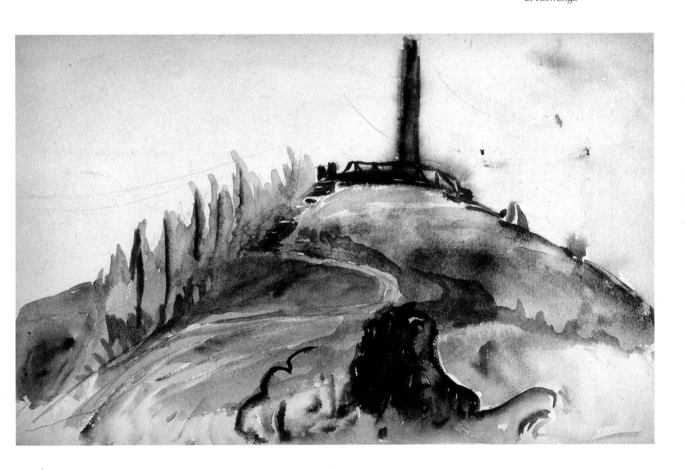

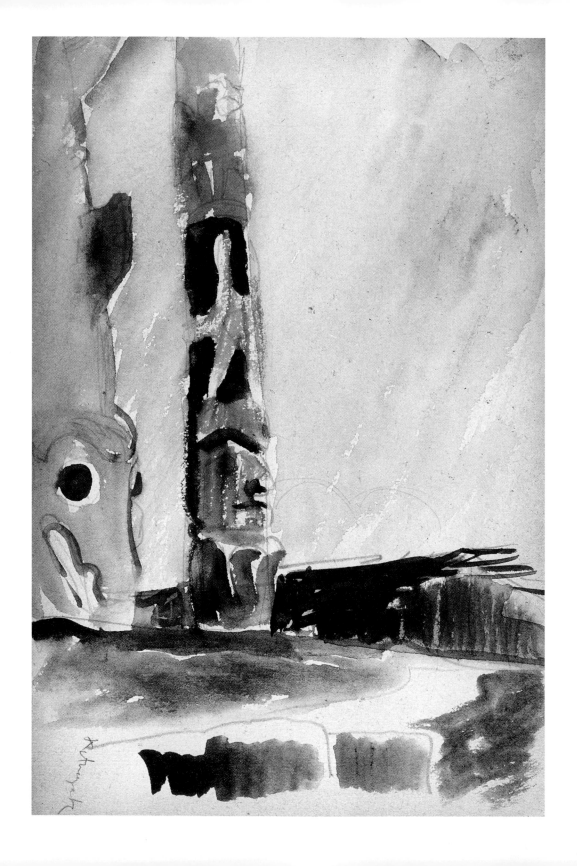

The highlight of this part of the trip was Kitwancool village, which Carr had not managed to visit in 1912 and where many fine poles were still standing; the most northerly of the Gitxsan villages, it was not then, nor is today, on a railway line. She did succeed in reaching it, however, and ended up staying five days, drawing eagerly from material that was new to her.

Leaving the Skeena River area, she made her way from Prince Rupert up the Nass River to Greenville. The Native community there was nearly empty as the inhabitants were away working at the cannery, but an old man, his wife and their grandchild, who had remained behind, found her accommodation in a dank and deserted schoolhouse away from the village on the edge of the forest and threateningly surrounded by rank growth. Greenville possessed no poles, but she persuaded an old man to take her up the river by rowboat to the Nisga'a villages of Angida and Gitiks, which she had not been able to visit in 1912.

Bad weather curtailed the ambitious hopes Carr had for a visit to the Queen Charlotte Islands, but she managed to sketch at Skidegate, Maude Island, Cumshewa, Tanu, South Bay and Skedans. The drawings she did of Skedans in one of these books—always in the rain, as she tells us—show the thoroughness and care of her

facing page:
*Kitwangak* [*sic*] *1928?*
Watercolour on paper
24.2 × 15.9 cm
B.C. Archives PDP05771

process in catching the compositional essence of a chosen scene with its tilting poles, viewing them now from this perspective, now from that, sometimes making colour notes.

Emily Carr, whose published writing is today probably at least as well known as her painting, recalled many of the experiences of this and other trips to Native sites as stories or anecdotes. In the short stories "Canoe" and "Greenville" in *Klee Wyck,* for instance, she describes those wild cattle at Fort Rupert and the frightening aloneness of her first night in Greenville. They are stories that make obvious and legitimate concessions to the dramatic or poetic demands she imposed on her experiences in their retelling many years later. But for immediacy and vividness, and some notion of the rigours of her venture as an ageing woman of fifty-seven years, nothing can match the letter she wrote to the director of the National Gallery, Eric Brown, and his wife, on August 11, from South Bay on the Queen Charlotte Islands, just a few days before her return to Victoria. She had met them in Ottawa six months before on her visit to the Canadian capital, and they knew about her plans for the trip. Ever a prolific letter writer, she wrote to them as to old friends who would naturally want to hear about her adventures:

*Kispiox* 1928?

Graphite on paper, 15.2 × 22.92 cm

B.C. Archives PDP05806

I've had a great trip with some good spots, some bad, some
exciting, and some trying, but I have enjoyed it all very much
and stood it remarkably well. First of all I went up the Skeena.
I found the poles greatly deteriorated in the last 15 years. The
restored ones have lost so much of interest and subtlety in the
process. I appreciate the difficulties of restoring them, and it is
certainly better to do it than let them utterly disappear, as they
must have in a few years, but that heavy load of all over paint
drowns them. I wish they would put on the preservatives and
leave the colour, not soak the whole pole in grey paint. . . . I went
in on a waggon with the chief and his son and was very well
treated. It is an awful waggon road—took 7 hours and nearly
bumped the life out of me. The heat and dust were terrific. . . .
I went in for ten days and got held up for five by a terrific
storm; it poured rain and hail for 4 days which made working
very difficult. I crawled into little grave houses which were
clammy, cold and leaky and always in the wrong spot to get the
right view. I was particularly sorry not to do some better stuff
there as the poles are very lovely. They are in shocking repair
but the carving is so tenderly done with great expression. I slept
out the first night but after the storm the Indians gave me a

corner of their house. It was a huge log affair, very clean,—
just one enormous room. The chief and his wife and son had
one corner, a married daughter, her husband and 3 children
another, and I had mine. . . . I was struck with the great resem-
blance of the women to the carved faces on the poles; they might
have been family portraits and probably some were. I worked in
a broken-down community house which gave scanty shelter and
was shared by some dozen Indian horses, who took all the dry
spots and left me the leaks. I shall get some stuff out of my
sketches but do wish I'd had fair weather. The mosquitoes up
the river were simply *fearful,* work was a torment and it was not
till I was fearfully bitten that I realized I *must* do something. It is
all very well for the camera man; he gets things quickly. But to
sit hour after hour and be eaten alive is fearful. All the Indians
sleep with nets. I constructed a costume, however, consisting
of a sack over my head with a small panel of glass let in the front
to see through. I had two pairs of gloves, one over the other, one
kid, and they bit through *both* pairs and a pair of heavy canvas
pantalettes that hung loose down to the soles of my shoes. I
was some beauty but managed to work. Was two weeks on the
Skeena during which time I had only one really fine day (though

facing page:
*(Group of poles at
Kitwancool)* 1928?
Graphite on paper, 15.2 × 22.9 cm
B.C. Archives PDP05802

this page:
*Kitwancool (poles and
buildings)* 1928
Graphite on paper, 15.2 × 22.9 cm
B.C. Archives PDP05779

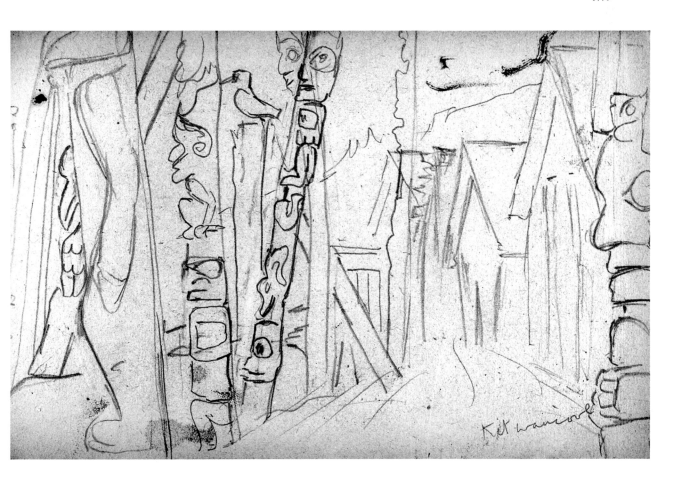

before that it was hot and I believe it was after). Then I went up
the Nass. The fish went with me, and from the day I got there the
cannery and boats were very busy and the mosquitoes were also.
I had to stick round the cannery most of the time but got away
for a week to 'Greenville' and lived in an empty school house
back in a mosquito swamp. Every soul in the village was away
except one man and woman who live a long way from my school
house. This man took me to the other villages in his own boat.
He had lumbago and one eye and was very lame, so all the pack-
ing fell on me. It was in this village I was particularly glad of the
company of my wee dog, 'Ginger Pop'. He is a tiny chap—six
lbs—but he is very brave and he's ruled all of the Indian dogs out
of their own villages with the air of an aristocrat. The Indians
think he is wonderful, and he has been great company in spooky
places and no trouble. . . . After returning to Prince Rupert and
sorting out my pack, I came on to Queen Charlotte Islands here. I
expected to get my best work and was very keen. I got to two vil-
lages and did quite a bit; then it has rained incessantly ever since
I came. Last Wednesday I contracted with an Indian who had a
gas boat to take me to three villages way off over bad waters.
It was supposed to be a good boat, and we got to the first village

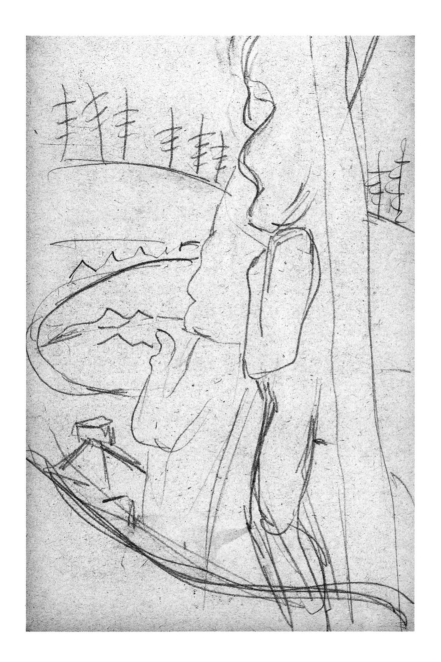

*(Poles in profile at Kitwancool)* 1928?
Graphite on paper, 24.8 × 15.2 cm
B.C. Archives PDP08757

There is a canvas on the same subject, *Totems, Kitwancool,* in the collection of Hart House at the University of Toronto

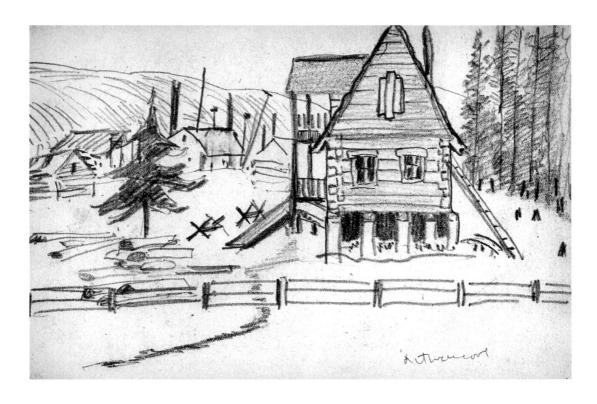

'Skedans'. I had been sick and got them to land me the first
moment (amid pouring rain); the man, his son and daughter
went back to the boat to have their dinner and suddenly a great
storm came up. They got the girl on shore, but the man and boy
had a fearful time; the boat was drifting fearfully, the engine
would not work and the anchors were fouled with the thick sea
weed. She had drifted so far they had a long way to row—it

was just awful watching. Time and time again the boat disappeared altogether. They never expected to make it nor I to see them again. . . . Just as it got dark a seine fishing boat caught our distress signals and came. I was glad to see the boat saved, but how I did hate going out on that awful sea. It was a party of Norwegians, They got our boat off the rocks and towed her behind, but we went on the big boat—oooooooh, I was sick. I lay flat on my back on the top of the fish hatch and did not care what happened the part that makes me sore is that I did not get to those other two villages. I'd contracted with the Indian for $50 for a 4-day trip. I had $50 worth of experiences but, oh, I did want my work. Travel round these islands really is terrific. Well, I should be thankful I have my life, for if the engine had gone bad before we got to land in that awful sea we'd all have been lost, and in spite of everything I have quite a bunch of work to keep me busy this winter from my sketches. Rain seems to have followed me everywhere.

Carr's drawings of poles and their settings in the sketchbooks from this 1928 trip are astute, summary records that do not stray from the visual evidence, though the canvases, for which she would

facing page:
*Kitwancool (village with poles in background)* 1928
Graphite on paper, 15.2 × 22.9 cm
B.C. Archives PDP05795

soon use some of them as starting points back in her studio, reveal how her attitude had been changing. In Ottawa and Toronto, the year before, Carr had opened herself to a view of art as a matter of expression and feeling, and consequently had come to see Native art, too, as great expressive works, into which she could read their makers' subjective intentions. Native artists "have searched beneath the surface for the hidden thing which is felt rather than seen, the reality . . . which underlies everything," she wrote in a supplement to the *McGill News* in 1929.

This shift in attitude led Emily Carr to paint some of her great canvases of Native subjects, but her wish to empathize sometimes led her astray in ethnological readings. In Kitwancool, as revealed both in the story of that name in *Klee Wyck* and echoed in the letter quoted above, she was moved by the strong presence of tender womanhood expressed in several poles on which a carved figure holds a child vertically between large wooden hands. "Womanhood was strong in Kitwancool," she wrote. Actually, according to anthropological information, the carved figures represent male beings in the mythology, not female, who, though the stories vary, were engaged in very unmotherly activity, however Carr liked to think of them.

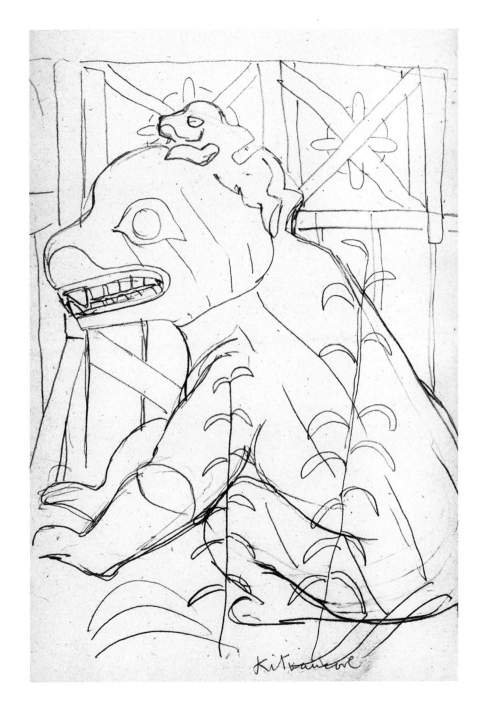

*Kitwancool (large carved figure)* 1928?
Graphite on paper, 22.9 × 15.2 cm
B.C. Archives PDP05778

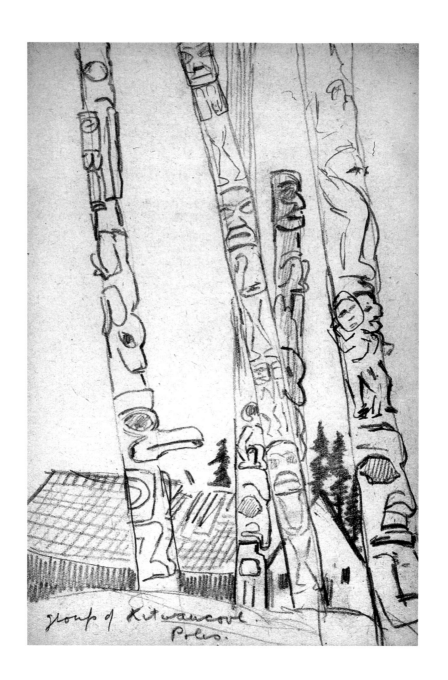

group of Kitwancool.
Poles.

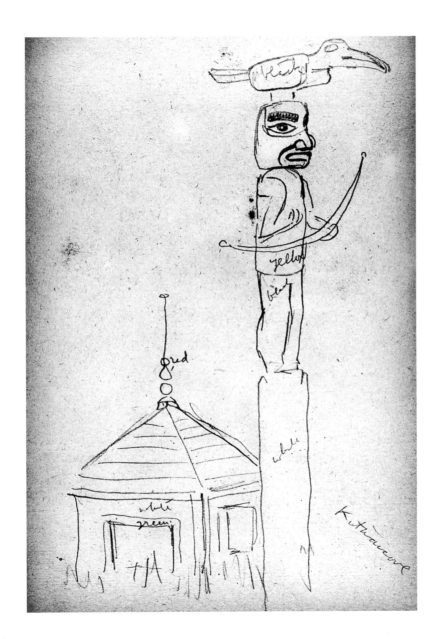

facing page:

*Group of Kitwancool
Poles* 1928

Graphite on paper, 22.9 × 15.2 cm

B.C. Archives PDP05801

this page:

*Kitwancool (pole and
building, with colour
notes)* 1928

Graphite on paper, 24.2 × 16.5 cm

B.C. Archives PDP05782

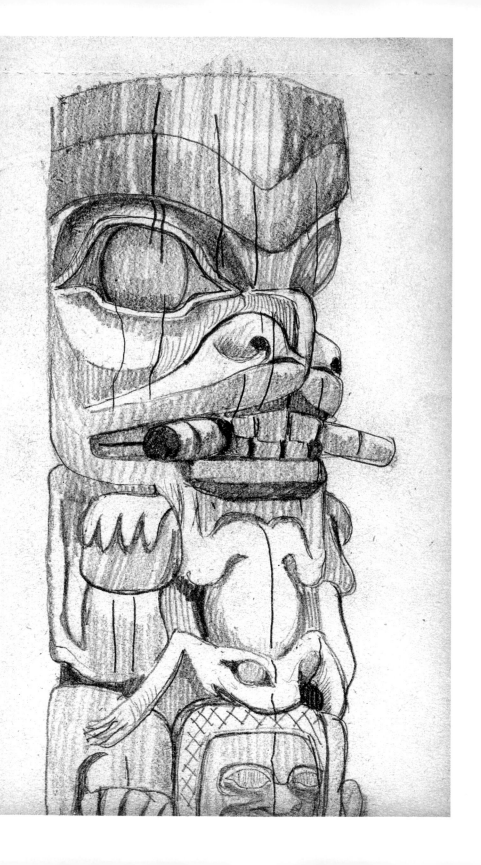

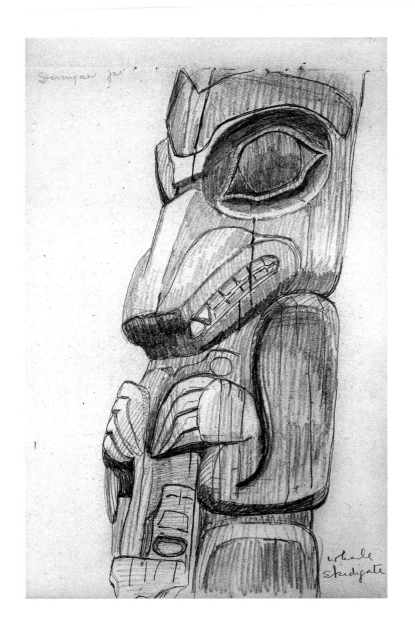

facing page:

*(Pole with beaver and frog at Skidegate)* 1928
Graphite on paper, 24.8 × 15.2 cm
B.C. Archives PDP08933

this page:

*Whale, Skidigate [sic]* 1928
Graphite on paper, 31.8 × 22.5 cm
B.C. Archives PDP08737

this page:
*(Eagle on top of pole
at Skidegate)* 1928
Graphite on paper, 24.8 × 15.2 cm
B.C. Archives PDP08934

facing page:
*(Two totem poles at
Maude Island)* 1928
Graphite on paper, 31.8 × 22.5 cm
B.C. Archives PDP08732

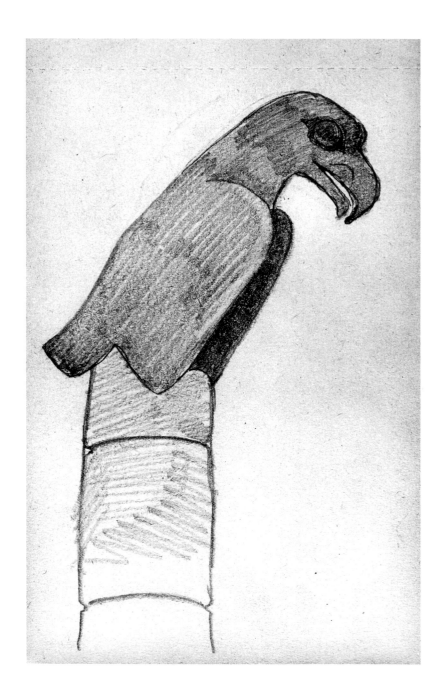

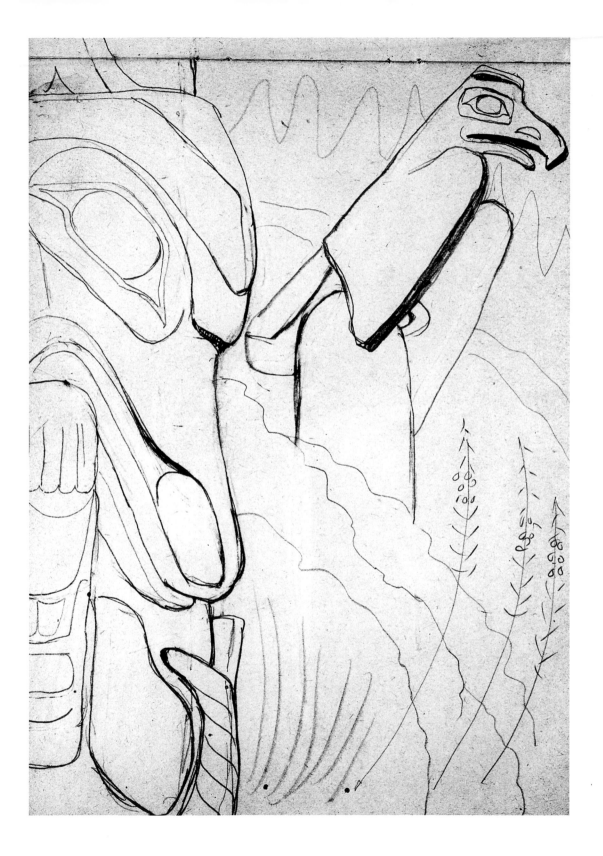

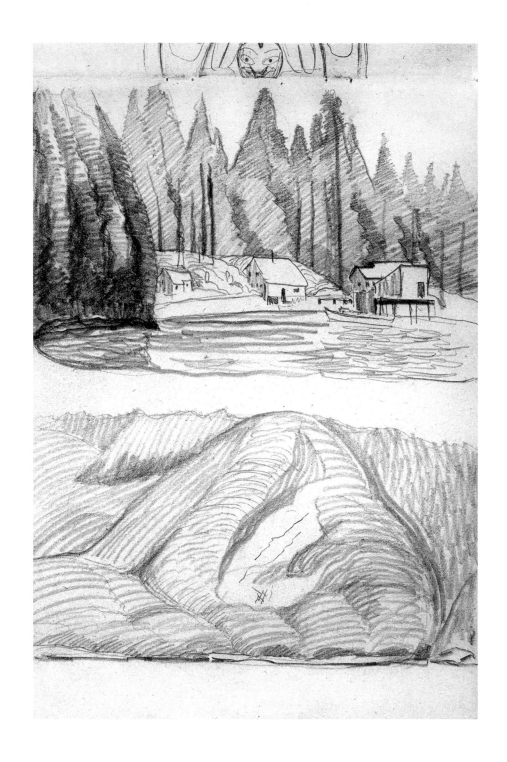

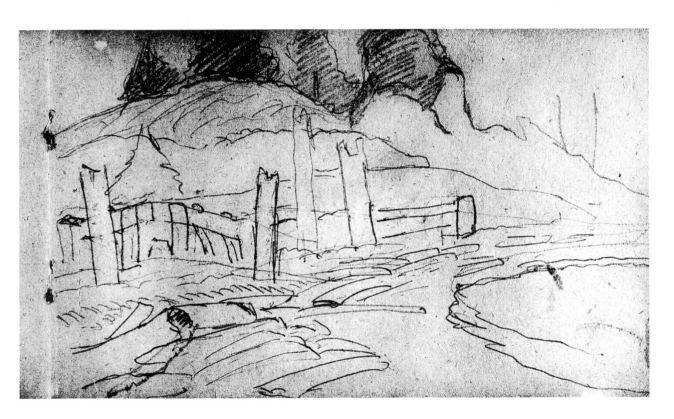

*(Old poles and house frames at Skedans)* 1928
Graphite on paper, 15.2 × 24.1 cm
B.C. Archives PDP08942

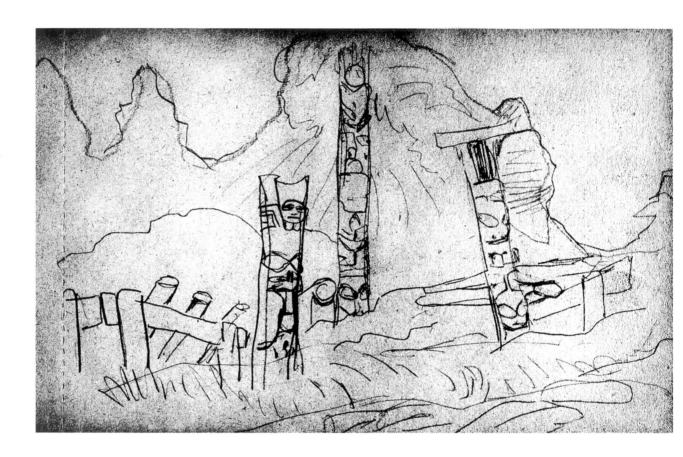

*(Three totem poles and
house frame in field at
Skedans)* 1928
Graphite on paper, 15.2 × 24.8 cm
B.C. Archives PDP08936

*(Totem poles at Skedans,
with colour notes)* 1928
Graphite on paper, 15.2 × 24.8 cm
B.C. Archives PDP08940

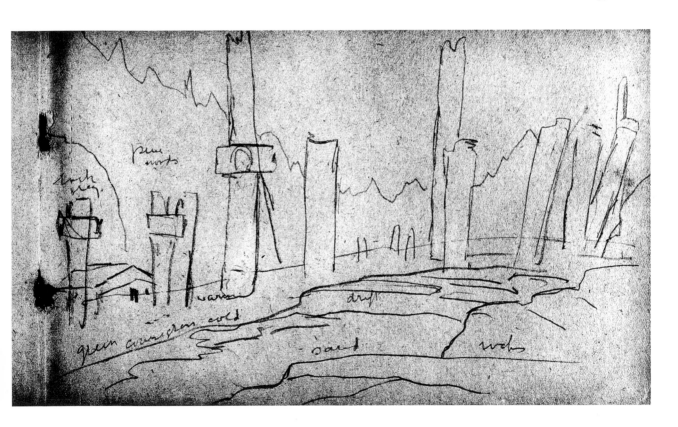

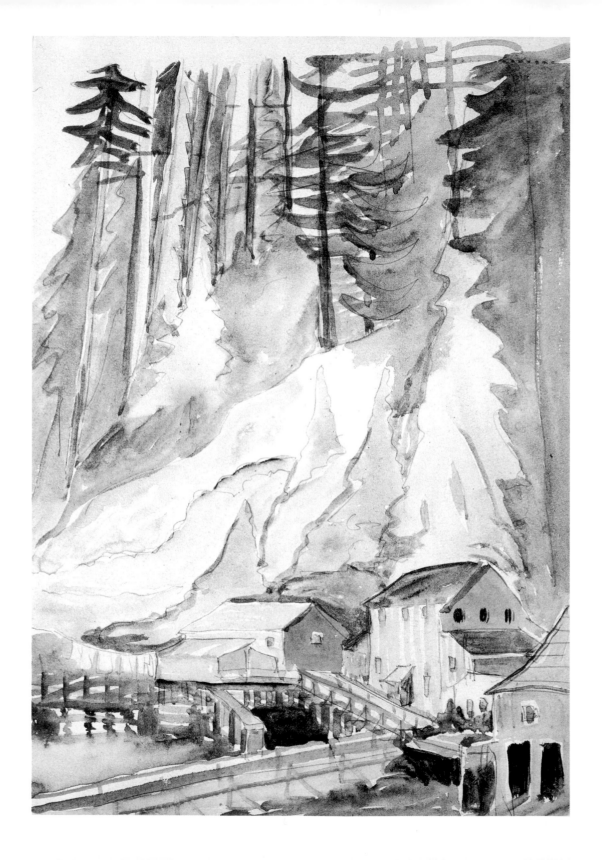

facing page:

*(Cannery with walkways,
against treed cliffs)* 1929
Graphite on paper, 31.8 × 22.5 cm
B.C. Archives PDP08744

## Nootka and Friendly Cove, 1929

NEVER AGAIN WOULD Emily Carr undertake such arduous travel as that 1928 trip, but she was not yet finished with Native subjects and made several shorter trips closer to home on Vancouver Island in the two summers ahead. In May 1929, she sailed north up the west coast, passing Ucluelet, the first Native village she had ever visited (an episode that she wrote about in *Klee Wyck*). The simple little line drawing shown here (page 82) must have been done from the boat, but her first visit on this journey was to the cannery community of Nootka on Nootka Island. "A wonderful trip," as she summed it up in her diary. She made notes on the way up in the boat: "We twist and turn among the islands and the sun plays hide and seek. The shacks here and there are grey and forsaken and broken—thrown together quickly—as quickly disintegrated—fragile temporary in contrast to the solidity and enduring of the sombre forests."

More written notes are inserted on several pages (facing page) in the drawing book:

Little rocky islands crammed so full of light green trees none can sit down. Bright yellow seaweed line then purple high water-mark then brown gold moss. / Thin whisps [sic] of mist travelling swiftly up the valleys / abandoned cabins, desolate & forlorn / and always the pines climbing climbing pointing up / the cedars yellowed with a swaying motion of long weeping branches / crows, bold & cheeky settling on the bow stealing large chunks & flying away to the beach followed by a squawking mob / black gulls swirling, wheeling crying dipping resting buoyant on the water / white point after point lapping over one another receeding [sic] dimly in the mist. / heavy clouds, grey water / stewards come out when work is done to smoke a quiet cig upon the after deck happy boys.

And on another page in the same sequence (facing page):

An island, wild & rugged. The highest tree bare and dead with an eagle's nest crowning it, above hovers the mother with her white

(*Two pages of handwritten text*) 1929
Graphite on paper,
each 24.1 × 15.9 cm
B.C. Archives PDP05704 (left),
PDP05705 (right)

A transcription of the text
appears on pages 76 and 79

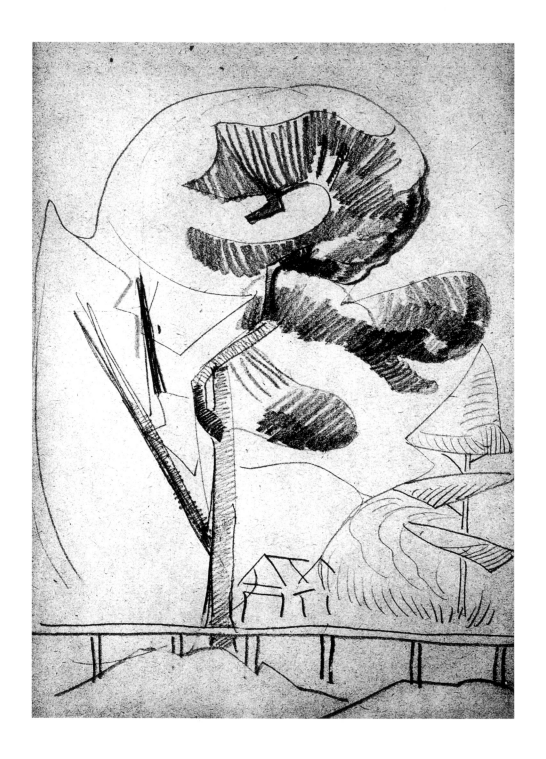

78

tail glistening like a truce flag. Papa sits below & yes—there is
a baby's head stretching up out of the nest black against the sky
grandeur freedom / The rocks are bare the sheer walls of rock
cold cruel dizzying—the trees creep into the crevisses [*sic*]. Even
the moss does not grow there / There is a snow peak with clouds
wrapped half round it is snowing there now, a little chill wind
creeps down the valley.

Once arrived at Nootka, Carr wrote: "The canneries are in
sheltered coves. Even the new ones look old. The west coast weath-
ers them soon." She made many drawings of the buildings, the
boardwalks built over the mud flats, the houses of the workers,
cabins abandoned and engulfed by growth where "the woods hang
dark and heavy. The moss on the rocks is sodden and filled with
water like sponges—the plank walk in front of the long row of red
houses with white window frames, uncurtained square are slippery
to a degree—it is well the handrails each side are well boarded to
the floor even tho the feet that patter along them are mostly bare."

Only a mile or so south of Nootka is Friendly Cove, a crescent-
shaped configuration formed by a gravel and sand spit, and a rocky
headland and islands. There, ships of many nations have found

protection from the unpredictable weather of Nootka Sound, including that of Captain James Cook in 1778, on his third and last voyage of discovery. The Native village of Yuquot is situated on the spit and connected by a path to Nootka; the rocky headland Carr described as "a nosegay of rocks bunched with trees spiced with wild flowers—topped with the light house crowned with its hopeful blinking light. The gulls circle round it. When the fog horn sounds—wow! It is wonderful, clean spaces—there is room to breathe, space to feel out into and think!"

Carr enjoyed staying for a week with the family of the lighthouse keeper in his comfortable house on that "strange wild perch" where the wind blew furiously, but "the foundation is solid rock— we are up far above the angry waves. The sun is beating down—but the breeze is cool and fresh." In the sketchbook from this trip, there are several drawings of the lighthouse which she did during her stay, as well as sketches of sites along the shore, though there are none of the little church that became the subject of one of her best-known canvases.

*(Nootka/Friendly Cove)* 1929
Graphite on paper, 15.2 × 22.9 cm
B.C. Archives PDP05680

Inscribed (sideways on right)
"house white & grey, sea
sparkling green, sun behind"
and (right bottom, on water)
"blue green"

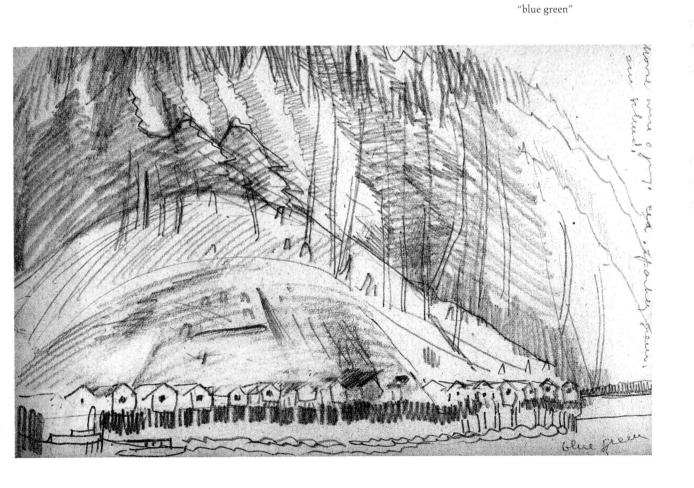

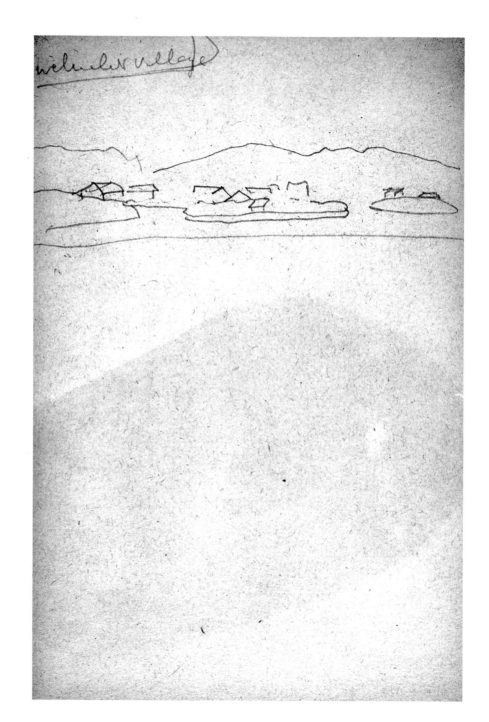

*Ucluelet Village* 1929?
Graphite on paper, 22.9 × 15.2 cm
B.C. Archives PDP05685

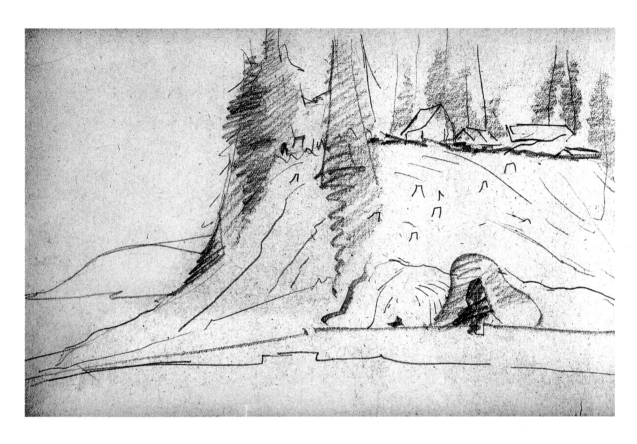

*(Buildings on top of cliff,
above sea)* 1929?

Graphite on paper, 15.2 × 22.9 cm

B.C. Archives PDP05682

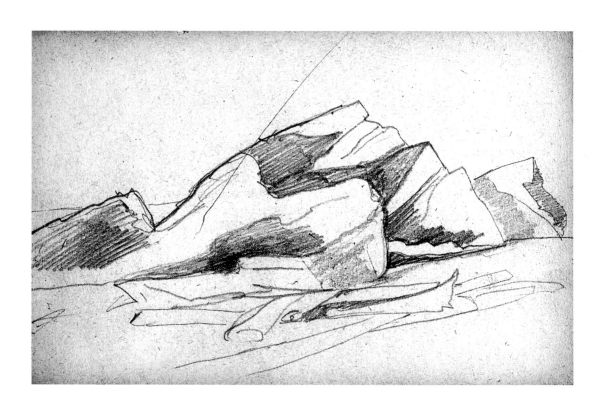

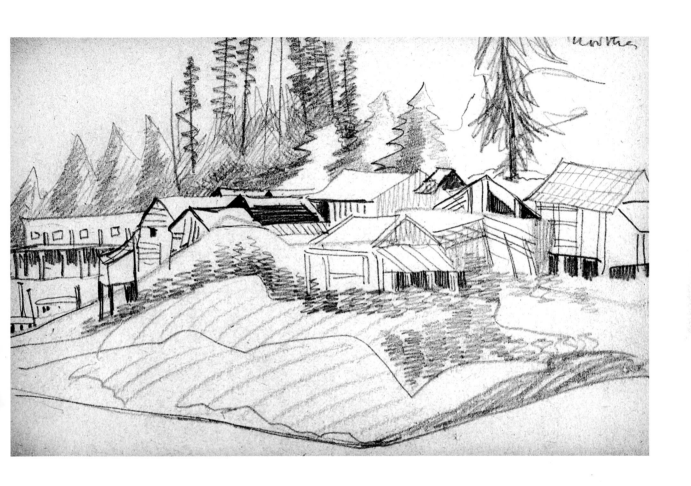

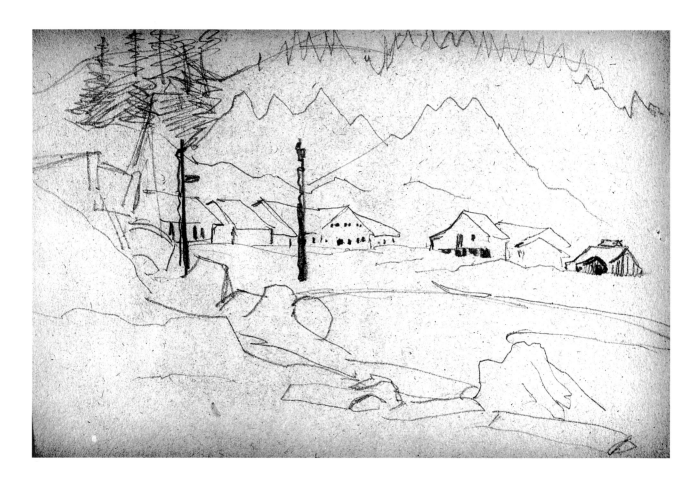

*(Coastal village with totem
poles)* 1929?
Graphite on paper, 22.5 × 31.8 cm
B.C. Archives PDP05698
Possibly the village of Yuquot at
Friendly Cove

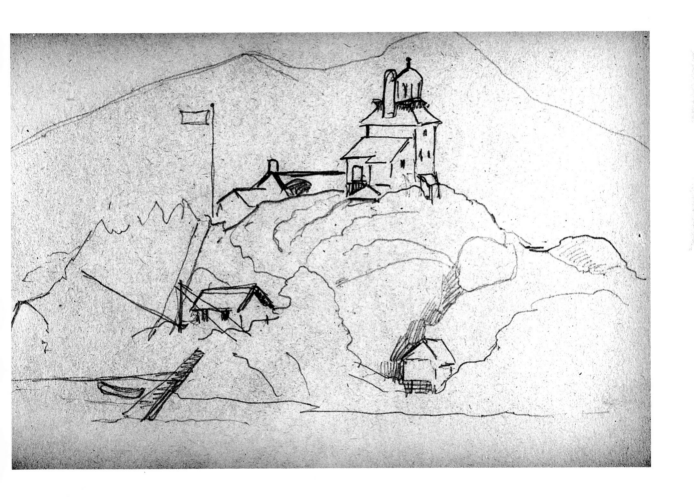

this page:

*(Friendly Cove and light-
house in distance) 1929?*

Graphite on paper, 15.2 × 22.9 cm

B.C. Archives PDP05706

facing page:

*(Cabin in forest engulfed
by swirling trees) 1929?*

Graphite on paper, 22.9 × 15.2 cm

B.C. Archives PDP05721

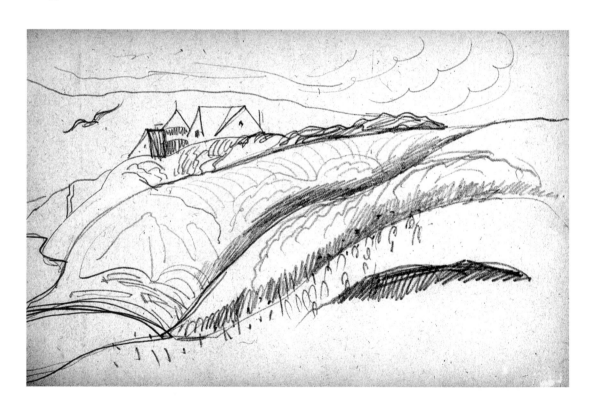

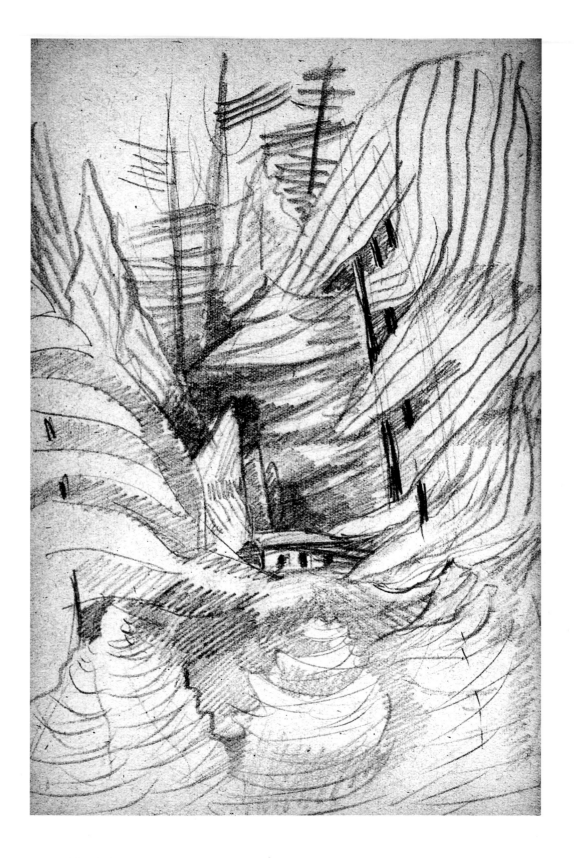

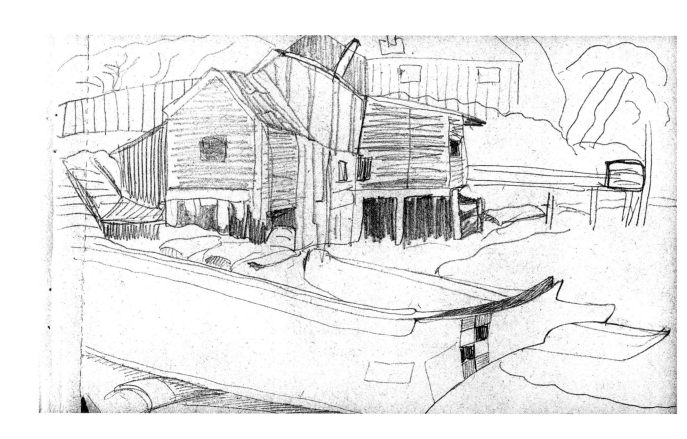

JOURNEY FIVE

## Port Renfrew, 1929

IN MID-AUGUST of 1929, Emily Carr set out again on the same
northerly route along the west coast of Vancouver Island that
she had taken a few months earlier in May, probably travelling
on the same steamer. This time, she went only as far as the first
stop, Port Renfrew, a mere five hours or so from Victoria. The visit
started off so unpromisingly that she headed her diary entry
"Renfrew Refuse," for what she found on leaving the boat was an
abandoned and desolate white settlement and cannery:

> The wharf was a sunken down affair—the shed had no doors
> now—it had had but they were lying inside on the floor among a
> litter of straw, paper and filth. . . . we passed down the gang-plank
> past the wharf light which wasn't lit though it was barely day-
> light, past the cannery that didn't can and the box factory that
> didn't box and the ruins of the hotel that had been burnt last

year and still littered the ground—the kitchen stove and the bed springs and other unburnables. We turned sharply and began to climb the hill past a cluster of houses—windowless shells that gave me the jim-jams.

Once on the cliff above, however, Carr discovered the Native village bustling with human activity, and her mood suddenly changed:

Joy, joy, joy—how splendid to be alive and to feel the sting of the fresh salt spray, to smell sea-weed and clam flats, to see the canoes bobbing on the waves or there on the beach, high and dry—so light they seem to rest almost on wings—a slightest push would send then skimming over the wet sand to join the others . . . the sun and the wind are in fierce battle as to who shall predominate and the great elements clean up the little village on the cliff, eating up waste and offal and driving the smells far out to sea.

The selection of drawings in this section is diverse, although most of them are from one sketchbook. The group is a difficult one to analyse, since the sketches were evidently done at different

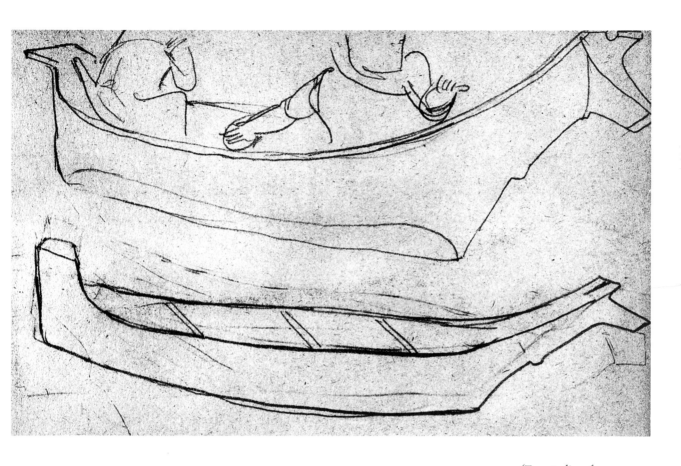

*(Two studies of canoes)* 1929
Graphite on paper, 14 × 24.1 cm
B.C. Archives PDP08797

*(Canoes and figures on beach)* 1929
Graphite on paper, 15.2 × 24.8 cm
B.C. Archives PDP08761

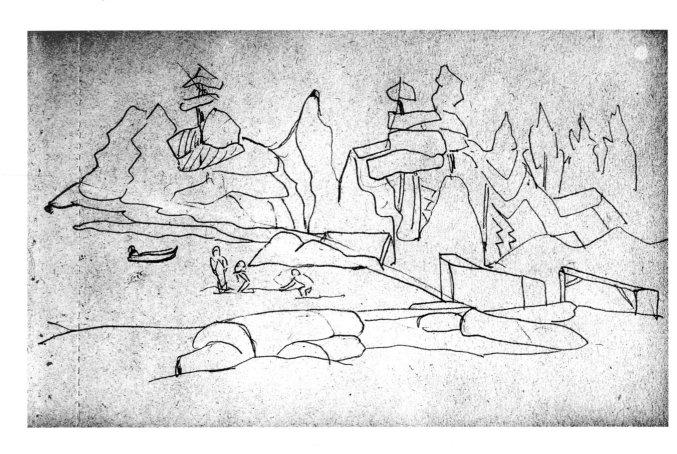

times and in different locations. To begin with, the cover is in-scribed in Emily Carr's hand with the word "Seattle" and with an address, presumably in Seattle. The first drawing, a windswept sky over a rocky shore (page 131), is inscribed "rhythm, weight, space," words that she had doubtless heard from Seattle artist Mark Tobey and had read in Ralph Pearson's book, words that encouraged her to emphasize abstract qualities of form in her work. There are also several drawings of her studio's paraphernalia—frames, brushes, etc.—again echoing subjects that Tobey was using at the time. And there is a sketch of a stylized tree that could have been made at any point along the way.

We do know, however, that the journey represented in this book included Carr's visit to Port Renfrew, wherever else she may have stopped, because of the drawings of whale and bear totem poles that are well identified as being located there. Her colour notes on these two drawings indicate her intention of developing paint-ings from them at a later date. And the many studies of canoes and the drawings of boys and young men sporting with the canoes visually convey her happy mood—also expressed in the quotation above—on first seeing the Native village on the cliff above the detritus of the old cannery.

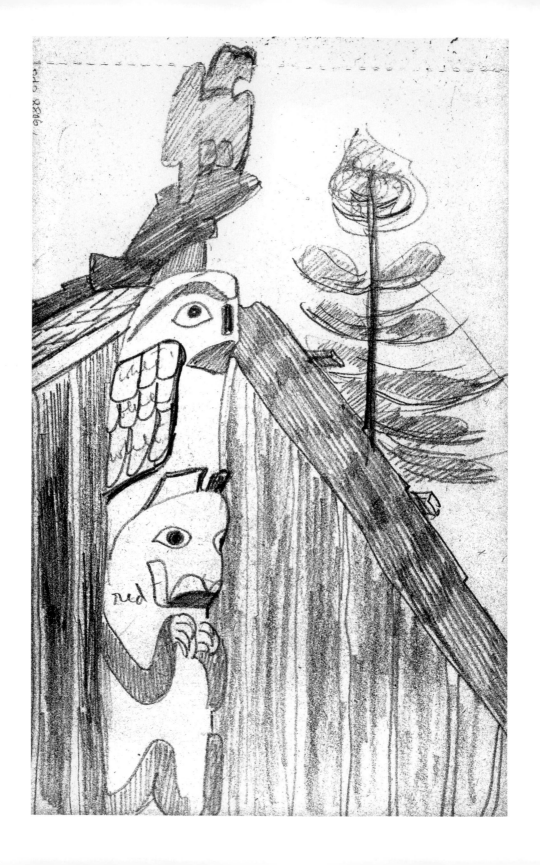

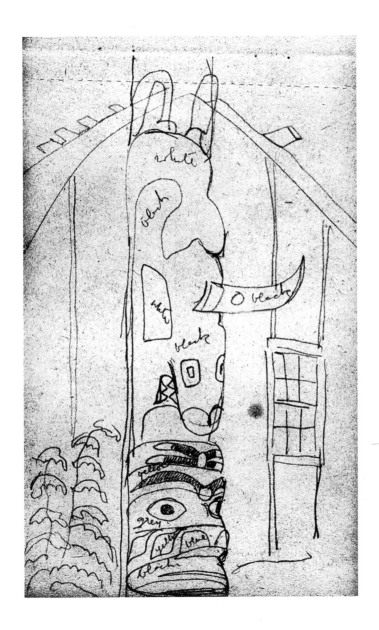

facing page:

*(Bear pole at Port Renfrew)* 1929

Graphite on paper, 24.1 × 14 cm

B.C. Archives PDP08806

this page:

*(Whale pole at Port Renfrew, with colour notes)* 1929

Graphite on paper, 24.1 × 14 cm

B.C. Archives PDP08808

The sketch on the facing page is probably "Chief Johnny's big bear." The one on this page is probably "Chief Toms house with the big whale pole in front." Both are described by Emily Carr in a journal entry dated August 1929, quoted by Paula Blanchard in *The Life of Emily Carr*, page 207

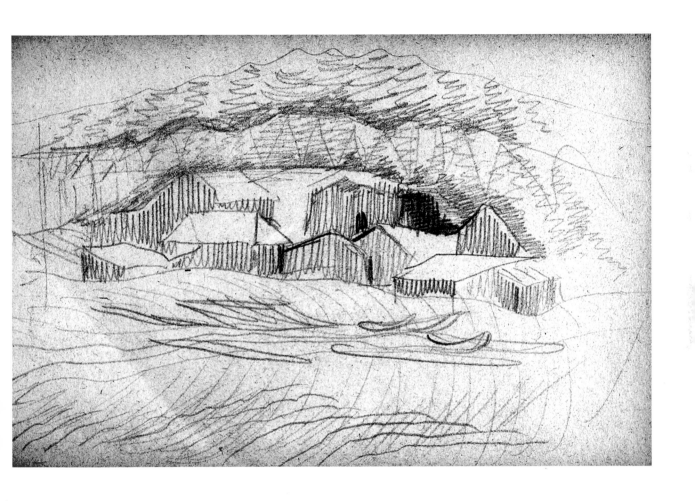

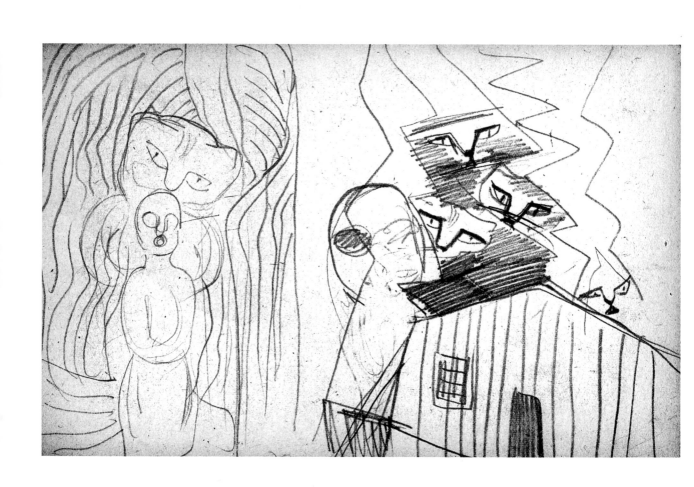

facing page:

*(Cats at Quatsino)* 1930?

Graphite on paper, 15.2 × 22.9 cm

B.C. Archives PDP05713

Quatsino is the
Kwakwa̱ka'wakw village that
Emily Carr called Koskimo

JOURNEY SIX

# Villages of Quatsino Sound (Koskimo), 1930

IN THE SPRING of 1930, Emily Carr made a second trip to eastern Canada, visiting her friends in Toronto again, stopping over in Ottawa, and this time continuing on to New York. There, among other things, she saw works by Wassily Kandinsky, Georges Braque, Aleksandr Archipenko and Marcel Duchamp (*Nude Descending a Staircase*). She also briefly met Georgia O'Keeffe and saw some of her paintings at the Stieglitz Gallery.

A few months after returning home to Victoria, Carr made the last of her trips to Native villages, starting out in mid-August for the northern end of Vancouver Island. She visited Alert Bay again and possibly other Kwakwa̱ka'wakw villages in the area, which by then must have been familiar territory to her, and then travelled around the tip of the island and down its west coast to Quatsino Sound. In the story "D'Sonoqua" in *Klee Wyck*, she describes a long smelly ride in a gas-powered mail boat, ragged tree-lined mountains edging the inlet and murky night water slapping a rail-less deck.

After a sleepless night in a rooming house that was there for the convenience of fishermen and loggers, Carr found someone who agreed to take her up the inlet and drop her off for the day at the village of Quatsino (which she called Koskimo). Even before she scrambled out of the boat onto the pebbly beach, a cat leaped aboard, the first of many that she encountered on that visit. The village itself, built as was customary with the houses facing the beach, was old, occupied though empty, for the villagers were away fishing. She wrote: "Nettles grew in the narrow spaces between the houses. I beat them down, and made my way over the bruised dark-smelling mass into a space of low jungle. Long ago the trees had been felled and left lying. Young forest had burst through the slash, making an impregnable barrier, and sealing up the secrets which lay behind it. An eagle flew out of the forest, circled the village and flew back again."

After forcing herself to push through the dense growth, a "secret" revealed itself: a huge carved figure with an open mouth and the mythical two-headed sea serpent, Sisiyutl, carved across its head. Carr mistakenly identified this as a figure of Dzunukwa (which she spelled various ways, including Dsonoqua, D'Sonoqua and Zunoqua), the mythical "wild woman of the woods," perhaps still under the spell of the Dzunukwa figure she *had* seen at

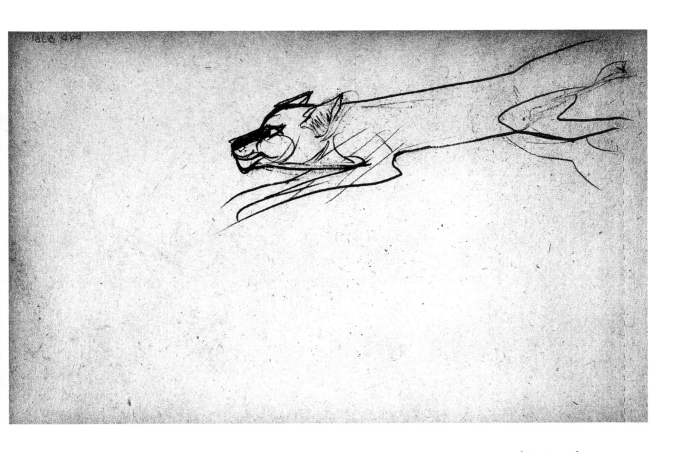

*(Drawing of a cat in motion)* 1930?
Graphite on paper, 15.2 × 22.9 cm
B.C. Archives PDP08781

*(Left to right: sketch of cats and two of Fort Rupert)* 1930?
Graphite on paper, 15.2 × 22.9 cm
B.C. Archives PDP05715

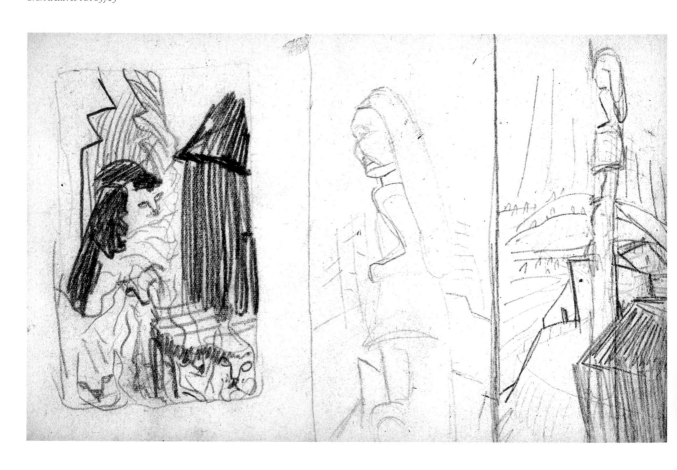

Gwayasdums in 1912 and a large canvas of which she was painting at just about this very time (now in the collection of the Art Gallery of Ontario). "I sat down to sketch. What was the noise of purring and rubbing going on about my feet? Cats. I rubbed my eyes to make sure I was seeing right, and counted a dozen of them. They jumped into my lap and sprang to my shoulders. They were real— and very feminine. . . . There we were—DSonoqua, the cats and I."

Mistaken identity or not, Carr's experience was intense, and among these sketches are some of her visual notes on the encounter, both the immanence of the figure and the improbable presence of the cats. Whether her studies of the cats in this book (pages 103, 106, and 107) were all done while on this trip we cannot tell, but they may belong to the same time frame, for they appear in the same book. The presence of a drawing of a Fort Rupert pole in a triptych format that includes a drawing relating to the cat experience (page 104) suggests that she may have also called at that village on this trip. It is interesting that the cat image in the triptych abandons the naturalistic approach of the other drawings in order to take on something of the bizarre nature of her experience. A canvas titled *Dsonoqua of the Cat Village*, a watercolour and a large drawing (in the collection of the Vancouver Art Gallery) also relate to this encounter.

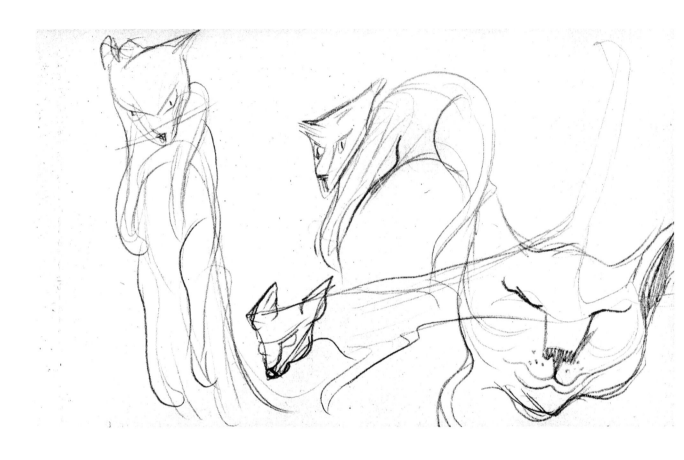

facing page:

*(Studies of cats)* 1930?

Graphite on paper, 15.2 × 22.9 cm

B.C. Archives PDP08780

this page:

*(Studies of cats)* 1930?

Graphite on paper, 14 × 24.1 cm

B.C. Archives PDP08776

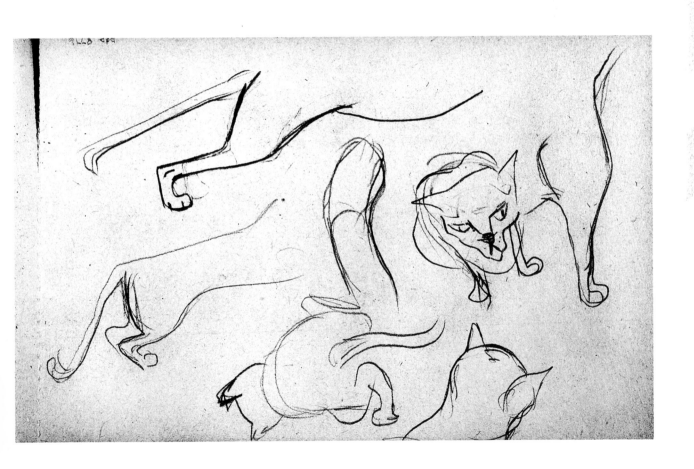

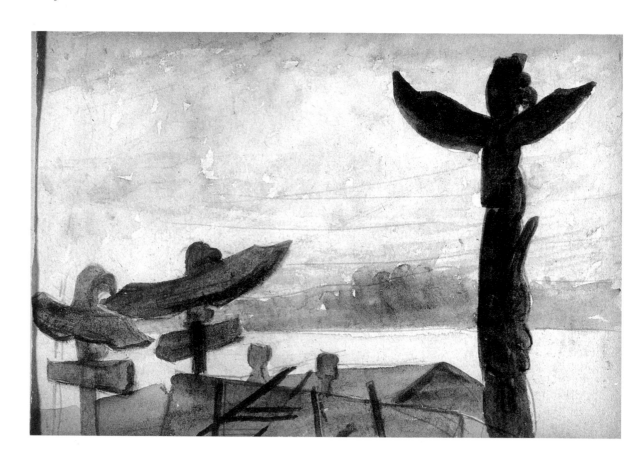

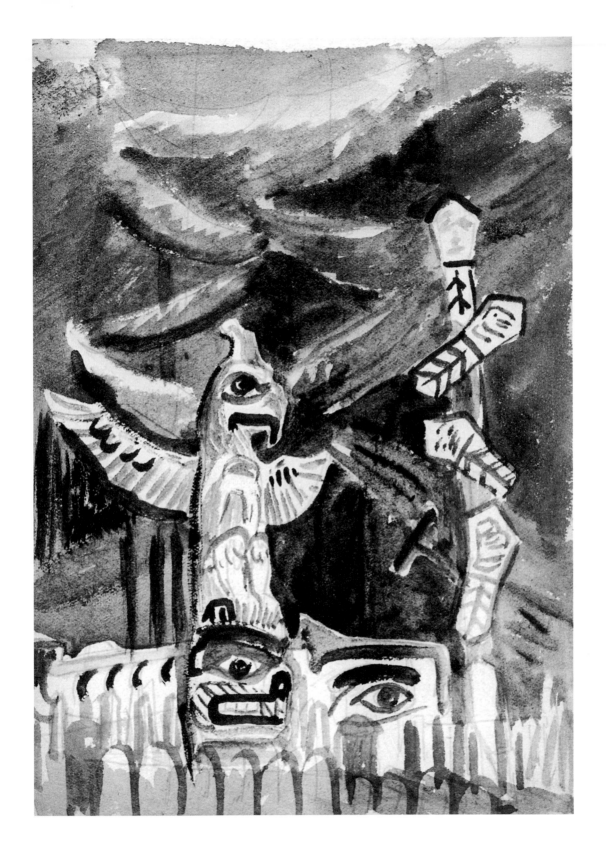

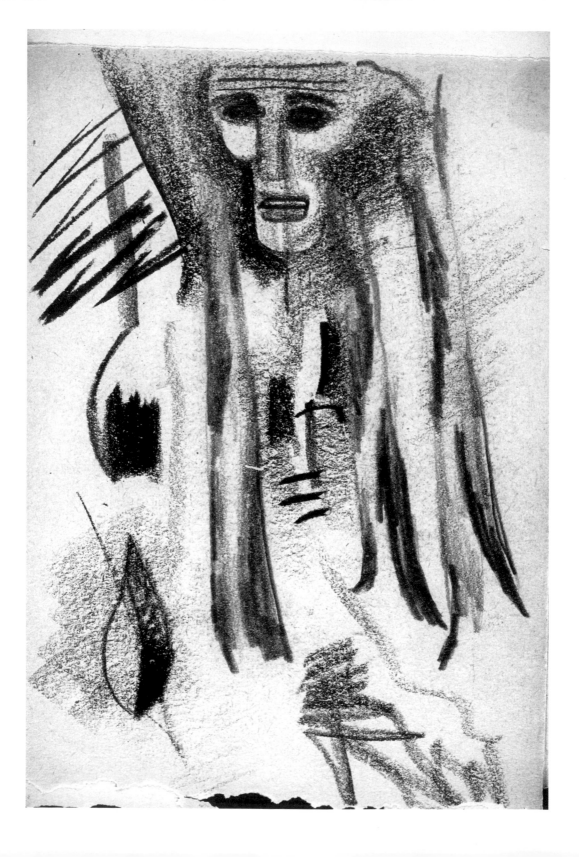

facing page:

*(Fusing of Native
imagery—a mask—and
forest forms)* 1930s

Graphite on paper, 31.8 × 22.5 cm

B.C. Archives PDP05854

JOURNEY SEVEN

## Into Nature, 1930 and Onward

EMILY CARR'S BRITISH COLUMBIA trips of the late 1920s had all had specific destinations: Native villages where she hoped to find fresh material for her continuing involvement with this theme. But this last group of drawings, selected from various books of the thirteen, follow her journey into the real and symbolic world of nature. This quest was one for which she had long been preparing and, in fact, was an intrinsic part of the many physical journeys she undertook during these nearly three years.

From a stylistic point of view, Carr's art during this time moved into and then well out of a phase of formal control and stylization and, from a thematic point of view, marked the approaching end of her preoccupation with Native subjects. The many drawings of Native sites in the sketchbooks are, for the most part, straightforward depictions. They do not suggest the emotionally charged canvases of brooding totems in the dark, thick, enclosing environments that she would develop from them between 1928 and 1930

(the last of them done in 1931) while under the spell of Lawren Harris. And also while, as her stories in *Klee Wyck* tell us, she was seeing the poles with the eyes of a romantic and herself as a stranger and alone, whatever human company she actually had with her on the journeys. She would still paint a few canvases of totem poles in her later years, but they would be reinterpretations of earlier work.

Since Carr's first delving into the area of Native culture, starting in 1907, the poles had served her well, permitting her to produce some distinctive work which would come to identify her with the west coast in the Canadian popular imagination. In her own artistic evolution, they had taken her into different places and kinds of nature: deep old-growth forest, rampant jungle and remote beaches, where she could get away from or out of sight of the spreading urbanized environs of Victoria. The sketchbooks reveal that, increasingly, whatever Native village might be her nominal destination, she was also reacting to and seeking out for the purposes of her changing art the various offerings of nature: striking individual trees, dense stands of trees climbing a cliff-side, a rolling line of hills, a pebbled shoreline with a tangle of driftwood.

Carr had always painted landscapes, from the little water-colours of Victoria meadows and woodsy paths made in her twenties, through the bold painterly canvases done during and after

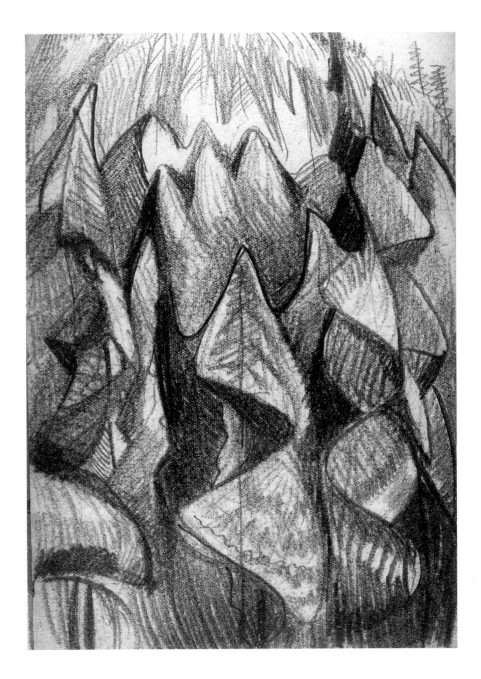

*(Stylized tree forms)* 1930s
Graphite on paper, 31.8 × 22.5 cm
B.C. Archives PDP05842

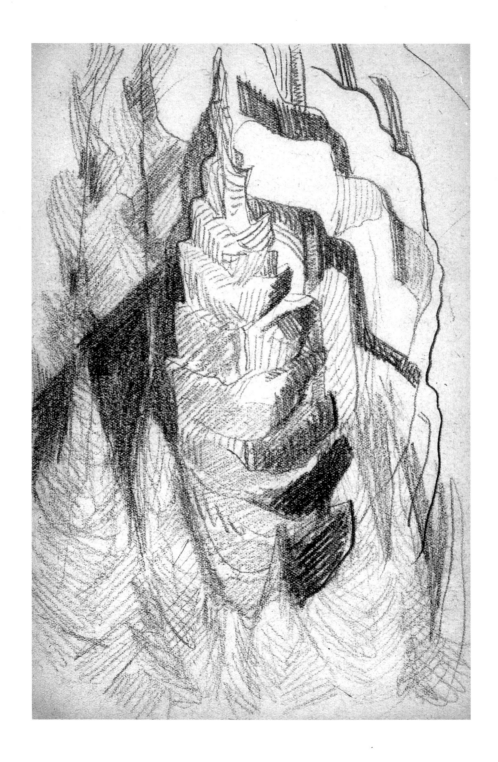

114

her artistic transformation in France. Landscape painting was a norm in Canadian art, and by the time she went east in 1927, the idea of a *Canadian* landscape—its unimaginable extent, its craggy promontories, its thick forests, its stretches of unpopulated terrain— had taken on a mythic role in the identification of the Canadian psyche. Carr, at least in her rhetoric, accepted this meaning that the land of Canada had acquired from those who had been instrumental in creating and giving it visual, tangible form, the Group of Seven, whose chosen painting territory was the rugged lake country of northern Ontario. After her encounter with them, human figures and activity, which had appeared in her early Native scenes and in her paintings of the French countryside, disappeared from her work.

With the marked exception of Lawren Harris, who went on to create his own symbolic realm of spirit in austere, arctic visions of ice-capped mountains and frozen seas illuminated by directed beams of hard light, members of the Group of Seven continued to paint landscapes: that is, particular places, particular scenes, forms of nature assembled for the eye out there in middle distance. Landscape painting in that sense, however, was not to be Carr's direction. When she left the Native theme behind around 1930, she was already on a path that was taking her *into* nature in a kind of

facing page:
*(Structured tree forms)* 1930s
Graphite on paper, 24.8 × 15.9 cm
B.C. Archives PDP05853

identification, not as an onlooker but a participant in its ongoing energy. In that particular extravagant natural environment where she lived, where the climate produced abundant rain-forest growth for much of the year, where she found constant reminders in nature of the persistence of growth in a continuing cycle of birth, death and regeneration, she found personal metaphors for a view of existence that answered her spiritual and emotional needs.

The pictorial means that Emily Carr found to convey this essence of nature in her art was movement, movement of all the kinds possible to a painter: sweeping, whirling, rolling, rising linear movements or jabbing, glittering brush strokes. It could be said that at this point in her work she ceased to paint landscape as such, that middle distance "out there" of conventional landscape. Movement and energy rush into and through and out the edges of her picture space, swallowing conventional depth distinctions of foreground, middle ground and distance, and consuming the discreteness of forms. In the late paintings, the energy finally comes to belong not to a particular place but to her mind, an imaginative construct she applied to all nature. Even when her subject was the painfully raw, stump-dotted terrain newly left by loggers, she charged her canvas or paper with an energy that contradicts the frame which serves as a container.

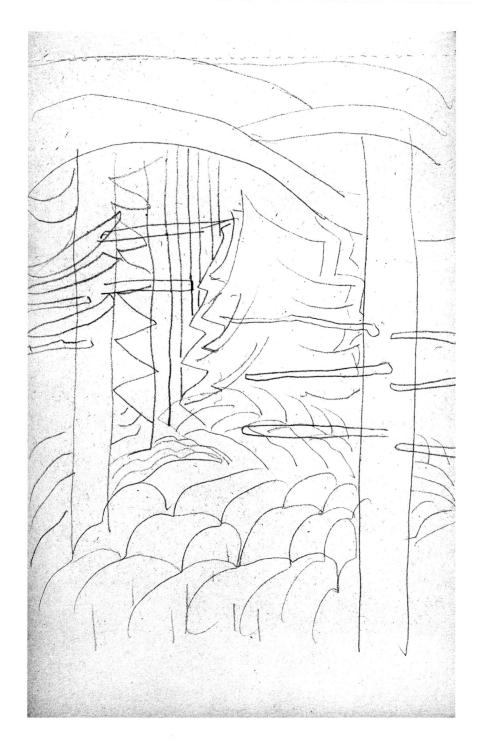

*(Forest forms with dead trees)* between 1925 and 1940

Graphite on paper, 24.8 × 15.2 cm

B.C. Archives PDP08760

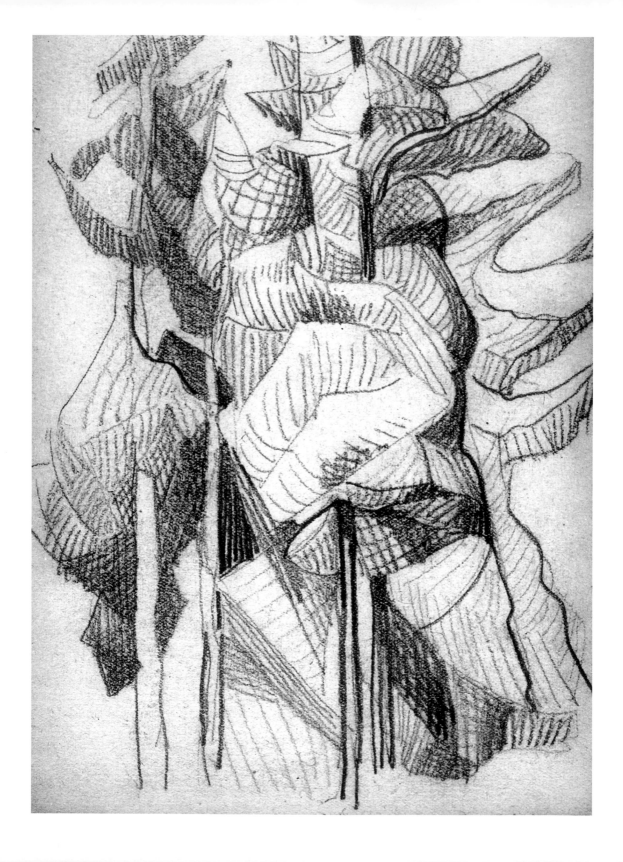

Glimpses of this transformation of discrete natural forms of nature into fields of energy of Carr's own visioning, as she was pulled away from the Native theme, are evident in these thirteen books of drawings. Her trip to the villages of Quatsino Sound in the summer of 1930 was not the last of her sketching excursions, but it did mark a shift in subject and locale. The following year, 1931, she began a regular practice of making summer sketching excursions to locations not too distant from Victoria, where, despite the encroachment of development, she could still find protected areas of forest, woods and lighter growth—or the ever nearby beaches and sea. She would find a cabin to rent or, after 1933, a place to park the camping "van" she had purchased. Carr always found her inspiration out of doors rather than in the studio, and the sketching trips lasted as long as she was physically able; the last one was in 1942, just three years before her death.

In a few sketches (one or two them included here) in the drawing books, she used an opaque pigment, heavily brushed on the absorbent paper. These might be regarded as early exploratory models for the oil-on-paper paintings that became her chosen medium for working outdoors after 1931, the principal vehicle for expressing her new sense of energy. The thin, quick-drying medium of

facing page:
*(Stylized tree forms with slender trunks)* 1930s
Graphite on paper, 22.9 × 15.2 cm
B.C. Archives PDP05851

gasoline and oil paint that she invented lent itself perfectly to the speed and spontaneity that her brush demanded.

And so, Emily Carr's last journey—which was one in perception and spiritual fulfilment rather than geographical—was not really a journey at all but a continuing part of her life. We have to examine her canvases and her oil-on-paper paintings to learn the full story, but there is illuminating evidence in these drawings of the observation, analysis and exploration of nature forms that constituted their foundation.

WE HAVE NOT YET had enough of Emily Carr, it seems, even more than fifty years after her death, for she sturdily remains part of today's ongoing critical dialogue. She continues to inspire new studies, new interpretations, and, in the process, she is acquiring a fuller dimension as, in the way of our time, she is placed in broader and sharper historical contexts: social, political, cultural and economic. She has, indeed, become an icon in Canadian culture. This small book of modest drawings in no way marks the exhaustion of Carr as the subject for further studies, revisionist or otherwise; and these works do add some fresh material to the visual oeuvre on which the mythology of Emily Carr ultimately rests.

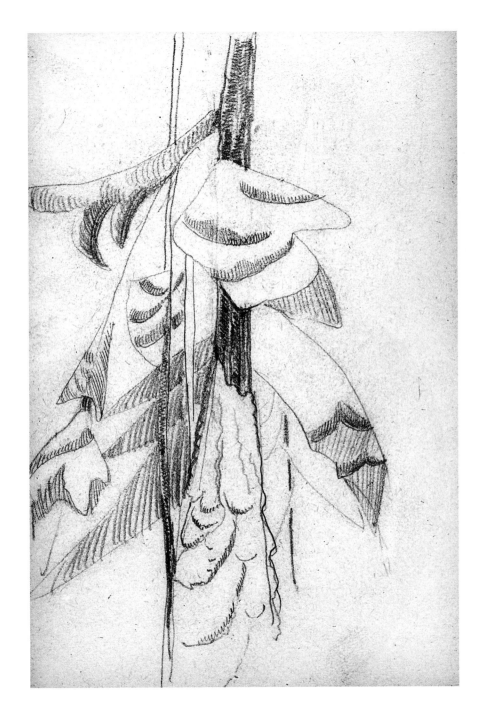

*(Stylized tree with
drooping forms
at Nootka)* 1929?
Graphite on paper, 22.9 × 15.2 cm
B.C. Archives PDP05709

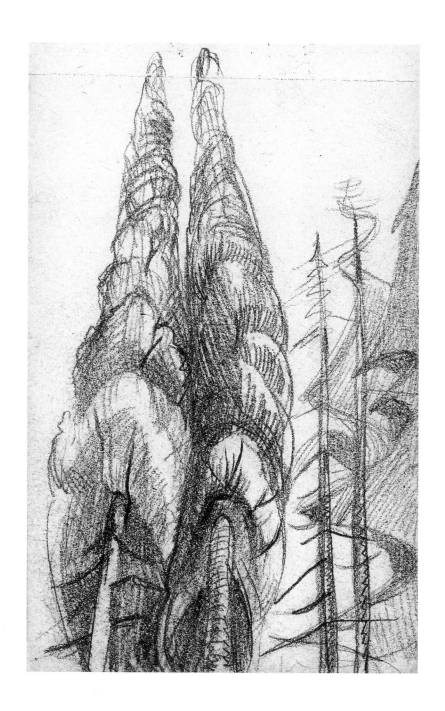

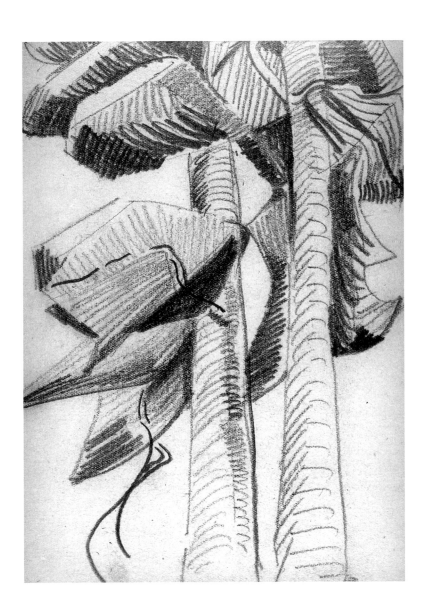

facing page:
*(Group of stylized trees)* 1930s
Graphite on paper, 22.9 × 15.2 cm
B.C. Archives PDP05829

this page:
*(Two stylized trees with vigorous branch formations)* 1930s
Graphite on paper, 31.8 × 22.5 cm
B.C. Archives PDP05844

this page:

*(Two sketches of trees with
thin trunks and swirling
foliage on one page)* 1930s

Graphite on paper, 15.2 × 22.9 cm

B.C. Archives PDP05678

facing page:

*(Tree study with
foreground rock)*

between 1925 and 1940

Graphite on paper, 22.5 × 31.8 cm

B.C. Archives PDP08749

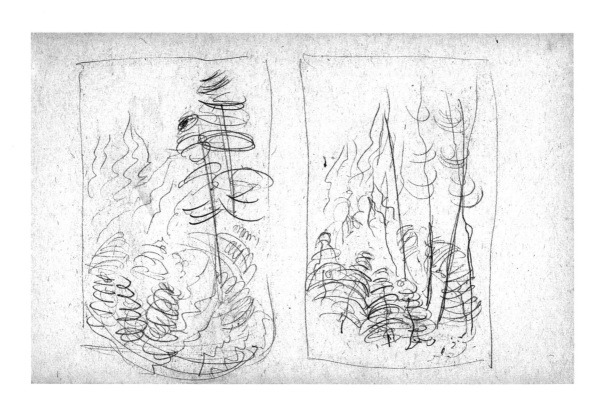

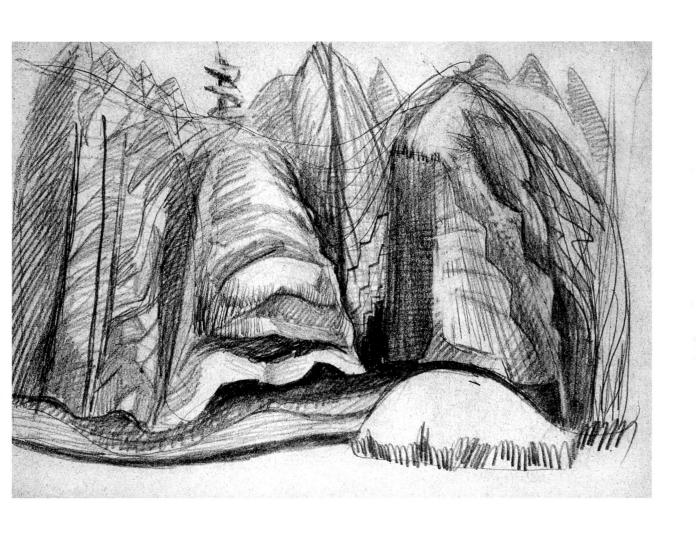

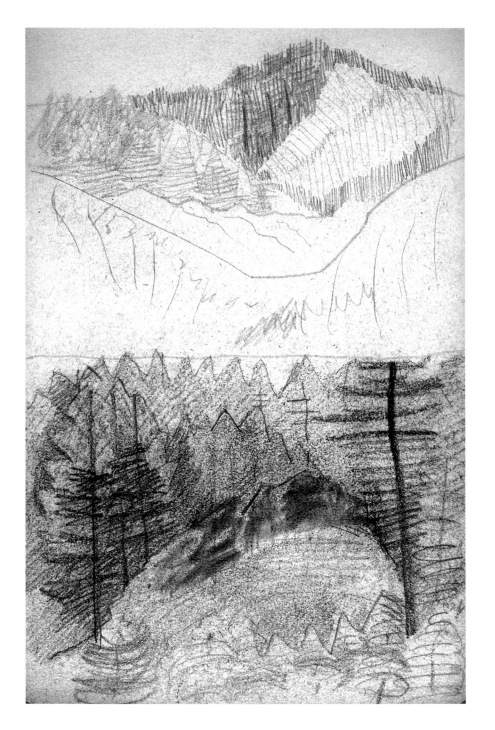

*(Two drawings of treed hillsides on one page)* 1930s
Graphite on paper, 22.9 × 15.2 cm
B.C. Archives PDP05619

(*Treed hills at the shore edge*) 1928

Graphite on paper, 15.2 × 22.9 cm

B.C. Archives PDP05756

Inscribed on right: duck for stool / [?] [?] / American cloth / teeth / Craig / Hamburg / letters / bank / post letters / petroleum / bran

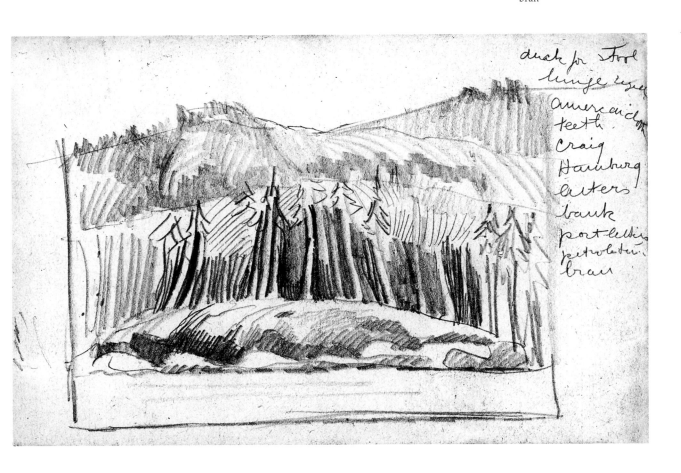

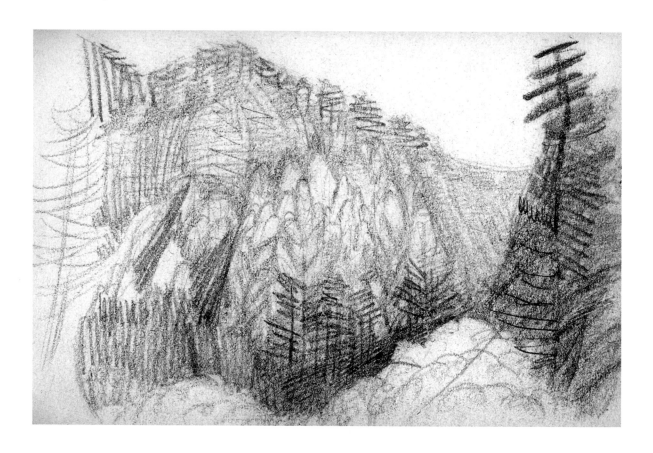

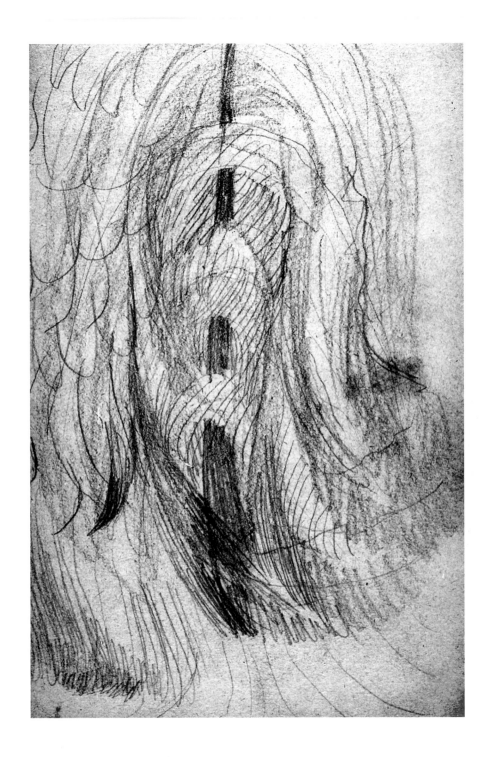

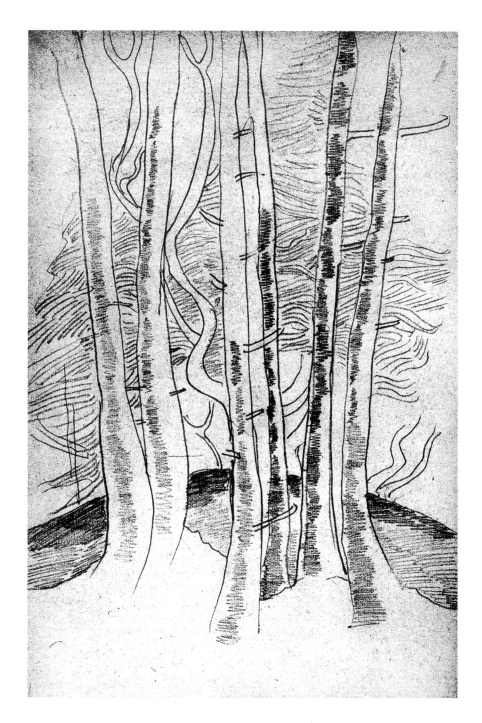

*(Line drawing of birch trees)* between 1925 and 1940
Graphite on paper, 23.5 × 15.2 cm
B.C. Archives PDP08785

*(Shoreline)* between
1925 and 1940
Graphite on paper, 15.2 × 24.8 cm
B.C. Archives PDP08794

Inscribed: "Rhythm weight
space force"

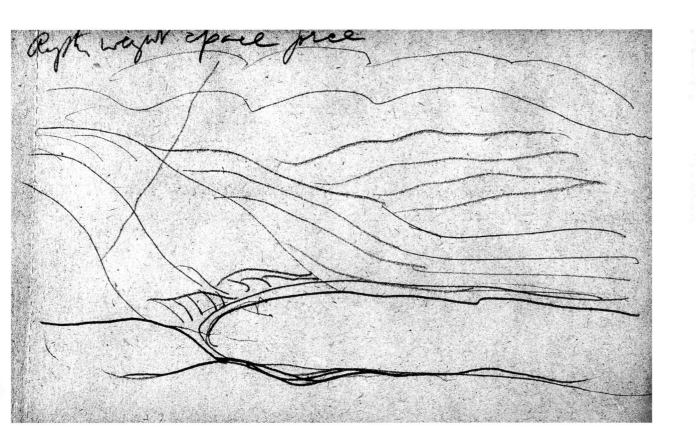

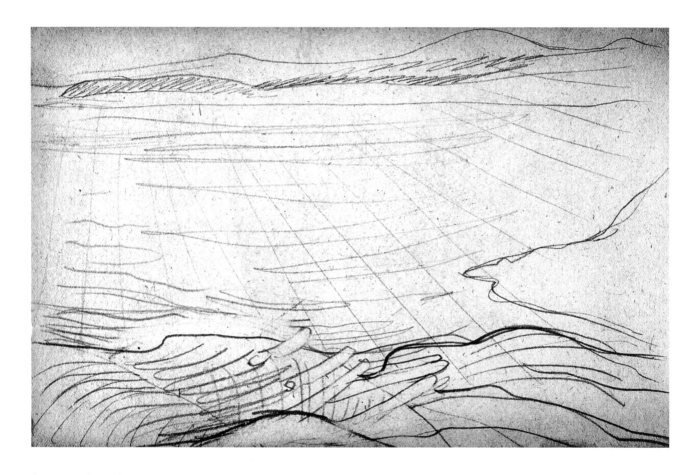

*(Drawing of sea edge)*
1930s
Graphite on paper, 22.5 × 31.8 cm
B.C. Archives PDP05636

*(Drawing of sea edge)*
1930s
Graphite on paper, 15.2 × 24.8 cm
B.C. Archives PDP05633

These two drawings depict
the same shore edge, with
varying lines of energy
and force

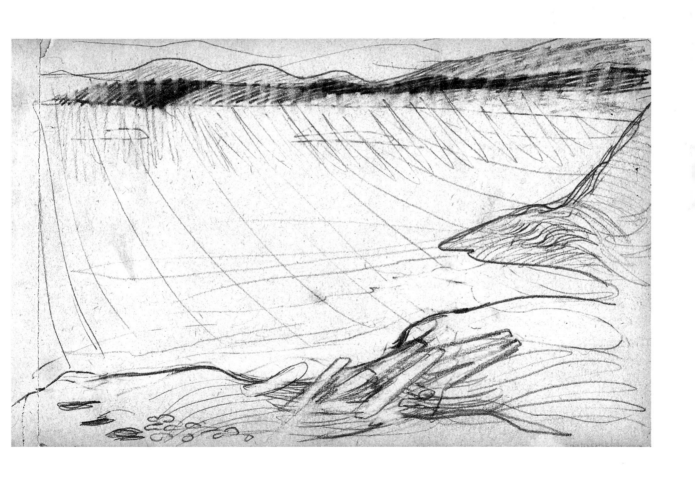

*(Shore edge)* 1930s
Watercolour on paper
15.2 × 24.8 cm
B.C. Archives PDP05645

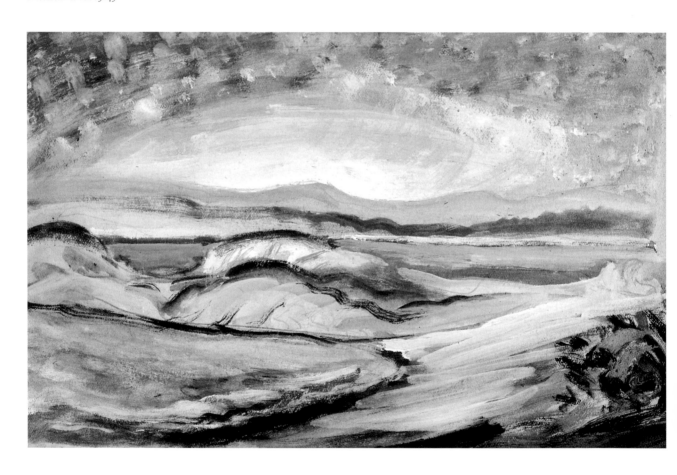

# EMILY CARR: A BRIEF CHRONOLOGY

*1863*
Richard Carr and his wife, Emily
Saunders Carr (both English,
though they met in San Francisco),
arrive in Victoria in the Colony of
Vancouver Island.

*1871*
Emily Carr is born 12 December in
Victoria. She has four older sisters:
Edith, Clara Louise, Elizabeth Emily
and Alice Mary.

*1886*
Mother dies.

*1888*
Father dies.

*1890–1893*
Studies at the California School of
Design in San Francisco.

*1899*
Makes her first visit to a Native
community, the Nuu-chah-nulth
village of Ucluelet on the west coast
of Vancouver Island. The Native
people give her the name Klee
Wyck, meaning "the laughing one."

*1899–1904*
Studies at the Westminster School
of Art in London and with various
artists. In June 1904, returns to
Canada.

*1907*
With her sister Alice, visits Alaska;
this is Emily's first real exposure to
Native monumental carving (which
was not a strong tradition among

the Coast Salish near Victoria or
the Nuu-chah-nulth at Ucluelet),
and she decides to document what
she perceives as a dying heritage.

*1908–1909*
Makes several journeys to the
Kwakwa̱ka'wakw villages of Alert
Bay, Campbell River and smaller
communities on northern Vancouver
Island. (The Kwakwa̱ka'wakw had
a well-developed tradition of
carving poles.)

*1910*
Leaves for France with her sister
Alice; in Paris, studies at the
Académie Colarossi, at the Atelier
Blanche and also has private lessons.

*1911*
Has two paintings in the 1911 *Salon
d'Automne* exhibition in Paris. In
November, she and Alice return
home to Victoria.

*1912*
Moves to Vancouver. In July,
sets out on a six-week expedition,
travelling alone. First, she journeys
up the east coast of Vancouver
Island to the Kwakwa̱ka'wakw
villages of Alert Bay, Mimquimlees,
Tsatsisnukwomi, Kalokwis, Cape
Mudge and Gwayasdums. Then, to
Prince Rupert on the mainland and
up the Skeena River to the Gitxsan
villages of Kitanmaks, Hagwilget
(a Carrier community), Kispiox,
Kitwanga and Kitsegukla. Next, to
the Queen Charlotte Islands (Haida
Gwaii) and the Haida villages of
Skidegate, Haina (on Maude Island),
Tanoo, Skedans, Cumshewa, Chaatl,
Yan and KaYang.

*1913*
In April, in Vancouver, holds a solo
exhibition of nearly two hundred
works on Native themes, and
also delivers a public lecture on the
subject. Returns to Victoria, and
from then on, until 1924, paints

much less, concentrating on making a living by taking in tenants and boarders in her small four-apartment revenue building.

*1924*
Makes contact with some painters, including Mark Tobey, in Seattle, Washington.

*1926*
Visited by ethnologist Dr. Marius Barbeau of the National Museum of Canada who, with Eric Brown, Director of the National Gallery of Canada, is planning an important show on Canadian west coast art.

*1927*
Eric Brown visits her studio in September to make a final selection for the exhibition. In November, she travels by train to the opening in Ottawa of *Canadian West Coast Art, Native and Modern* (also shown in Toronto and Montreal). En route, she stops off in Toronto to meet

members of the Group of Seven, particularly Lawren Harris, with whom she begins a correspondence about art and spirituality.

*1928*
Actively resumes painting. In July and August, makes a two-month-long solo journey north. First, to the Kwakwaka'wakw villages of Alert Bay and Fort Rupert, and smaller communities. Next, to the mainland and up the Skeena River to the Gitxsan villages of Kitwanga, Kispiox, Kitsegukla and Kitwancool (which she had been unable to visit in her 1912 trip), then to the Nass River and the Native communities of Lakalzap (at Greenville), Gitiks and Angida. Finally, to the Queen Charlotte Islands (Haida Gwaii) and the Haida villages of Skidegate, Alliford Bay, Maude Island, Skedans, Cumshewa and South Bay.

In September, invites Seattle artist Mark Tobey to teach a master class at her studio and works with him for three weeks.

*1929*

Writes an article "Modern and Indian Art" on Native art and her travels to Native villages for the *Supplement to the McGill News* in Montreal.

In May, travels to the community of Nootka on the west coast of Vancouver Island and sketches at nearby Friendly Cove, site of the Native village of Yuquot. In August, takes a steamer to visit Port Renfrew on the island.

*1930*

Her first solo shows: at the Canadian National Railway office in Ottawa, at the Crystal Garden in Victoria and at the Art Institute of Seattle. In March, travels to see her solo show in Ottawa, then to see the Group of Seven show (including six of her works) at the Art Gallery of Toronto, and on to New York for a week visiting museums and galleries, where she meets Georgia O'Keeffe.

In August, makes her last trip north: visits Alert Bay and takes the mail boat around the tip of the island to small Native villages on Quatsino Sound on the west coast.

*1931*

In May, goes on a local sketching trip with her friend Edythe Hembroff to Cordova Bay. In the autumn, goes on a solo local sketching trip to Sooke Hills and later (with Hembroff) to Goldstream Park.

*1932*

In May, goes on a local sketching trip with Edythe Hembroff to Braden Mountain in the Sooke Hills. In June, goes on a brief solo local sketching trip to Mount Douglas.

*1933*

Buys a metal caravan, which she nicknames "the Elephant," for local sketching trips, the first in August to Goldstream Park.

Makes a trip to the east (her last), to the Chicago World's Fair to see the international art exhibition (which suddenly closed before her arrival) and to Toronto to see the Canadian Group of Painters exhibition (which includes two of her works) at the Art Gallery of Toronto.

*1934*

Writes the first story about her childhood, "Cow Yard" (the seed of the later *Book of Small*). In May and September, goes on month-long local sketching trips in her caravan to Esquimalt Lagoon near Victoria.

*1935*

Spends part of May, all of June and most of September in her caravan, sketching at Albert Head near Victoria.

*1936*

In September, takes the caravan on a week-long local sketching trip. Solo show at Hart House, University of Toronto.

*1937*

Writes a number of stories about her experiences with Native people (many later published in *Klee Wyck*). Solo show at the Art Gallery of Toronto.

*1938*

Writes a manuscript later published as *Pause*. Solo show at the Vancouver Art Gallery, held annually thereafter (except for 1942) until her death. Makes first of four local sketching trips from 1938 to 1940.

*1941*

Her first book, *Klee Wyck,* is published and wins the Governor General's Award for non-fiction.

*1942*

Her second book, *The Book of Small,* is published. In July, goes on her last sketching trip, renting a shack at Mount Douglas Park for ten days.

*1943*

Major retrospective at the Art Gallery of Toronto, with smaller ones in Montreal, Vancouver and Seattle.

*1944*

Her third book, *The House of All Sorts,* is published. Solo show at the Dominion Gallery in Montreal, her first at a commercial venue.

*1945*

Emily Carr dies on the afternoon of March 2.

*1946*

*Growing Pains* published (at Carr's request, publication was delayed until after her death). Other posthumous publications include *Pause* (1953), *The Heart of a Peacock* (1953), *An Address by Emily Carr* (1955), *Hundreds and Thousands* (1966) and *Fresh Seeing* (1972).